THE SPECTA CULAR OF VERNA CULAR

Published on the occasion of the exhibition *The Spectacular of Vernacular*, curated by Darsie Alexander and organized by the Walker Art Center, Minneapolis.

Walker Art Center
Minneapolis, Minnesota
January 29–May 8, 2011

Contemporary Arts Museum Houston
Houston, Texas
July 23–September 18, 2011

Montclair Art Museum
Montclair, New Jersey
October 8, 2011–January 1, 2012

Ackland Art Museum at the University of North Carolina at Chapel Hill
Chapel Hill, North Carolina
January 14–March 18, 2012

The Spectacular of Vernacular is made possible by generous support from the Andy Warhol Foundation for the Visual Arts, Helen and Peter Warwick, and the Margaret and Angus Wurtele Family Foundation.

The exhibition catalogue is made possible by a grant from the Andrew W. Mellon Foundation in support of Walker Art Center publications.

Available through D.A.P./Distributed Art Publishers, 155 Sixth Avenue, New York, NY 10013. www.artbook.com

Design Director: Emmet Byrne
Designer: Dante Carlos
Editors: Kathleen McLean and Pamela Johnson
Publications Director: Lisa Middag
Imaging Specialist: Greg Beckel

Printed in the USA by Shapco Printing, Inc., Minneapolis

Typeface: Berthold Akzidenz Grotesk
Paper: Finch Opaque

Cover: Lari Pittman *A Decorated Chronology of Insistence and Resignation #30* 1994 Private collection Courtesy Regen Projects, Los Angeles

John Brinckerhoff Jackson's essay is excerpted from his book *Discovering the Vernacular Landscape*, ©1984 and reprinted by permission of Yale University Press.

Library of Congress Cataloging-in-Publication Data

The spectacular of vernacular / organized by Darsie Alexander ; texts by Darsie Alexander, Andy Sturdevant, and John Brinckerhoff Jackson. – 1st pbk. ed.
 p. cm.
 Published on the occasion of an exhibition held at the Walker Art Center, Minneapolis. Minn. and three other institutions between Jan. 29, 2011 and Mar. 18, 2012.
 Includes bibliographical references.
 ISBN 978-0-935640-99-1 (pbk. : alk. paper)
 1. Art, American–20th century–
Themes, motives–Exhibitions. 2. Art, American–21st century–Themes,
motives–Exhibitions. 3. Material culture in art–Exhibitions. I. Alexander, M. Darsie. II. Sturdevant, Andy. III. Jackson, John Brinckerhoff, 1909-1996. IV. Walker Art Center.
 N6512.S6585 2011
 709.73'074776579–dc22

 2010054069

WALKER ART CENTER, MINNEAPOLIS

THE SPECTA CULAR OF VERNA CULAR

ORGANIZED BY DARSIE ALEXANDER

WITH CONTRIBUTIONS BY JOHN BRINCKERHOFF JACKSON,
ANDY STURDEVANT, AND CAMILLE WASHINGTON

FOREWORD

OLGA VISO

FOREWORD

For many, that which constitutes American culture is in a state of constant flux as a barrage of influences redefines, almost daily, what we perceive as native to our artistic language and production. Indeed, the very categories we use to identify "American" art have loosened and are expanding to encompass a staggering diversity of platforms and aesthetics. In this era of borderless and participatory forums of exchange, *The Spectacular of Vernacular* explores the role of culturally specific iconography in the increasingly global world of art.

Inspired by artist Mike Kelley's observation that "the mass culture of today is the folk art of tomorrow," Walker chief curator Darsie Alexander has created a tantalizing and visually arresting exhibition reflecting an expanded and highly nuanced view of material culture's pervasive impact on contemporary art. It offers a perspective that embraces the totems, billboards, and neon signs of roadside America as well as the nostalgia, rituals, and relics that survive in homes, local thrift shops, and the collective memory. This material culture of the United States, as Alexander points out, has served as a wellspring of inspiration for a range of visual artists since the 1960s. Through strategic selections that capture varied practices and influences ranging from rustic to urban vernacular, the show traces this history in diverse and dynamic ways.

The Spectacular of Vernacular is the first exhibition to consider how and why many artists continue to vigorously assert a dialogue with specific customs and traditions as embodied in the notion of the North American vernacular, drawing inspiration from objects associated with informal, often personal modes of creativity. For the artists included here, this point of departure provides a platform for narratives centered on sense of place, social ritual, and home life. Their work runs the aesthetic spectrum from sleek to handcrafted, underscoring the diverse manifestations of the vernacular within our lived environment. Often appearing labor-intensive and meticulously fashioned, the works featured here attest to the vibrancy of under-recognized forms of casual creativity and production, often stemming from idiosyncratic sources that have not, to date, been the subject of in-depth art-historical research. I applaud Alexander for venturing into this rich terrain in the contemporary visual arts. This is a task she has accomplished with her usual verve and grace, informed by a voracious curiosity and a keen and rigorous intellect.

This accompanying publication considers the reasons that may be motivating a widespread interest in this subject, both for the specific artists involved and within the broader cultural climate of our times. Here the curator unravels the current understandings of the notion of the vernacular and brings alive its many complex forms and myriad contradictions as manifested in the works of late twentieth- and early twenty-first-century artists. John Brinckerhoff Jackson offers singular insights on this important subject from his seminal 1984 reader *Discovering the Vernacular Landscape*, and Minnesota-based writer

and curator Andy Sturdevant reflects on the evolution of roadside vernacular and attendant histories of heartland America.

For many reasons, the Walker Art Center seemed an ideal home for such a project. Located in the country's heartland, it is surrounded by vernacular of a particularly Midwestern slant, visible in the localized dwellings, customs, and craft of this part of the United States. As anyone who moves to the Twin Cities from elsewhere knows, it is a place uniquely conditioned by weather and geography, themes that, as historical literature would have it, are among an array of factors informing regional vernacular. At the same time, the global context of our daily reality is constantly changing the look and function of the vernacular, with influences arriving from around the world to alter facets of folk and material culture locally.

This project would not have been possible without the lenders and their representatives who played key roles in facilitating loans for the exhibition, and thanks are due the following individuals: vice president and director Dorian Bergen, ACA Galleries, New York; chief curator of painting and sculpture Ann Temkin and deputy director of exhibitions and collections Ramona Bronkar Bannayan, Museum of Modern Art, New York; partner Ted Bonin, Alexander and Bonin, New York; director Carla Chammas and registrar Mae Petra-Wong, CRG Galleries, New York; director Renee Coppola, Tanya Bonakdar Gallery, New York; chief curator and associate director for programs Donna DeSalvo and permanent collection curator Dana Miller, Whitney Museum of American Art, New York; Corinna Durland and Lisa Williams, Gavin Brown's Enterprise, New York; codirectors Janine Foeller and Jane Hait, and gallery manager Elizabeth Lovero, Wallspace, New York; associate director Erin Fowler, Richard Gray Gallery, Chicago; directors Carol Greene and Alexandra Tuttle and artist liaison Anna Fisher, Greene Naftali Gallery, New York; director C. Sean Horton, Horton Gallery, New York; registrar Mary LaGue, Taubman Museum of Art, Roanoke, Virginia; associate curator Christian Peterson, department of photography and new media, Minneapolis Institute of Arts, Minneapolis; Grace Matthews, Faith Ringgold Studio, New York; executive director Cecile Panzieri, Sean Kelly Gallery, New York; Shaun Caley Regen, Brad Hudson Thomas, and Jennifer Loh, Regen Projects, Los Angeles; sales director Adam Sheffer, Cheim & Read, New York; director Simone Subal, Peter Blum Gallery, New York; Mary-Clare Stevens, Kelley Studio, Los Angeles; director Janelle Reiring, Metro Pictures, New York; gallery manager Melissa Tolar, David Kordansky Gallery, Los Angeles; curator Gilbert Vicario, Des Moines Art Center; Sachiyo Yoshimoto, Jim Shaw Studio, Los Angeles; and managing director Wendy Williams, Louise Bourgeois Studio, New York.

Assembling such an exhibition necessarily requires the ample efforts and manifold talents of colleagues and financial supporters. The staff at the Walker brought characteristic dedication and creativity to this

project from the outset. Deepest gratitude must be paid to the members of the visual arts department, all of whom were supportive of this idea from its inception. Camille Washington, curatorial fellow for diversity in the arts, deserves special acknowledgement for her contribution to this publication and virtually every facet of the exhibition. She put together the annotated reading list of arts criticism and cultural studies for the catalogue, and assiduously tracked details large and small—from loans and press releases to floor plans and photo credits—with an easygoing demeanor and unabated optimism. Curator Siri Engberg poured over the proofs for this catalogue, providing many valuable and insightful suggestions. Assistant director of exhibition planning Lynn Dierks managed contracts and agreements with an impressive blend of accuracy and patience. Department assistant DeAnn Thyse helped maintain order as an endless flow of deadlines unfurled. Assistant curator Bartholomew Ryan explored the possibilities of the exhibition, including the artists it might encompass, during its early phase of development while former research intern Elizabeth Henderson compiled valuable data on artists and available works as a checklist was honed. Curator Elizabeth Carpenter and curatorial assistant Eric Crosby stepped in when needed to offer a helping hand at various stages of the project's development. David E. Little, Alexander's husband, lent his support at critical moments of the book's evolution and supplied incisive commentary on its themes.

Fondest appreciation is due to registrar Gwen Bitz, who navigated the organization, installation, and tour of the show with extraordinary care and expertise. Senior registration technician David Bartley and registration technician Evan Reiter ably oversaw the care of the works during storage and packaging. Endless thanks to program services director Cameron Zebrun and the outstanding crew, led by Kirk McCall, all of whom finessed the final look and feel of the Walker installation with exceptional skill and adaptability.

Senior designer Dante Carlos deserves particular recognition for the wealth of references, creative ideas, and generosity he brought to the design process, resulting in the singular and lively appearance of this publication. Editors Kathleen McLean and Pamela Johnson oversaw all texts associated with the exhibition and publication with aplomb, delving into the content with natural inquisitiveness and thoughtful attention to detail. Chief of communications and audience engagement and curator of design and architecture Andrew Blauvelt, design director Emmet Byrne, and publications director Lisa Middag ably supervised the production of this book, providing guidance during its development and gently spurring us toward its completion. Senior imaging specialist Greg Beckel ensured that images were of the highest quality, and Walker photographers Cameron Wittig and Gene Pittman contributed essential photographs for the book.

Chief of finance and development Christopher Stevens, director of special projects fund-raising Marla Stack, and special projects devel-

opment associates Annie Schmidt and Aaron Mack worked to secure its realization through a directed fund-raising campaign. Thanks are due to annual fund director Scott Winter and Patrons' Circle development associate Masami Kawazato for their contributions to the dynamic events attending the opening of the show. Chief of operations and administration Phillip Bahar and chief financial officer and treasurer Mary Polta adeptly provided thoughtful administrative oversight throughout the show's development. Education and community programs director Sarah Schultz offered a helpful sounding board as the exhibition developed, and public and community programs manager Ashley Duffalo and her colleagues adeptly coordinated all related public programs. New media initiatives director Robin Dowden and her skilled staff ensured that the impact of this exhibition was made beyond printed materials and gallery walls. Librarian Rosemary Furtak, archivist Jill Vuchetich, and visual resources librarian Barb Economon offered essential assistance throughout all stages of research. Support was also provided by Ryan French, director of marketing and public relations, associate director of public relations Karen Gysin, associate director of marketing and research Adrienne Wiseman, and staff writer Julie Caniglia, each of whom helped make this topic of conversation known locally and nationally.

We also appreciate the efforts of our colleagues and collaborators at institutions around the United States for bringing this exhibition and the work it contains to their communities: Bill Arning, director, and Valerie Cassel Oliver, senior curator, Contemporary Arts Museum Houston; Gail Stavitsky, chief curator, Montclair Art Museum; and director Emily Kass and chief curator Peter Nisbet, Ackland Art Museum. Located in disparate parts of the country, these organizations approach the subject from their own unique perspectives and "vernaculars," expanding the show's themes as it travels through the country.

Early and generous contributions came from the Andy Warhol Foundation for the Visual Arts, New York, an organization devoted to the unconditional support of artists and curators thinking experimentally and working today. We are grateful to Warhol Foundation president Joel Wachs and program officer Pamela Clapp for their critical support of this endeavor. Walker trustee Peter Warwick and his wife, Helen, and honorary trustee Angus Wurtele and his wife, Margaret, generously aligned their support with this exhibition, and we gratefully acknowledge them.

Finally, the ideas and content of the exhibition rest with the people whose work gives it reason to exist—the artists who are its true subject. Each deserves his or her own individual thanks for producing work of lasting resonance, and for generously taking the time to host our visits, give telephone interviews, and answer endless detailed queries in the months before the opening. We are especially grateful to St. Paul–based artist Chris Larson for creating a site-specific project for the

FOREWORD

Walker's Cargill Lounge. Bringing the outside indoors, this new work subtly amplifies the exhibition, engaging audiences in dynamic and surprising ways.

Through this exhibition, Alexander has begun to distill some of the central themes of the vernacular for artists working today, affirming the institution's dedication to the arts community of Minnesota while bringing a high degree of awareness of artistic developments occurring nationally and internationally. Such a balance is integral to the Walker's identity as an arts center and gathering place for creative producers near and far.

Olga Viso
Executive Director

THE MASS CULTURE OF TODAY

IS THE FOLK ART OF TOMORROW.

—MIKE KELLEY [01]

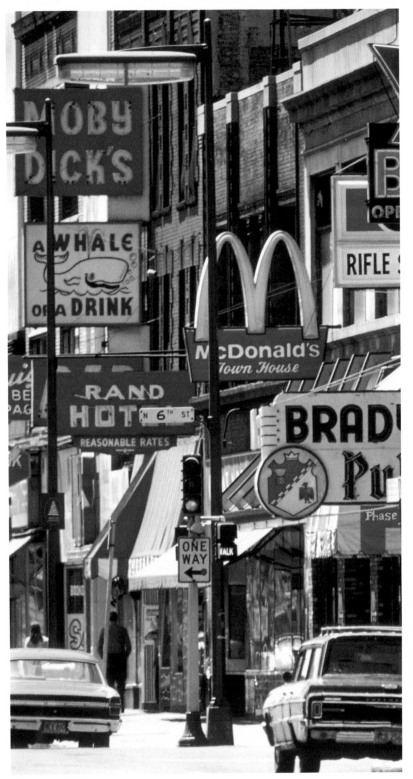

Hennepin Avenue, downtown Minneapolis, 1973

THE SPECTACULAR OF VERNACULAR

DARSIE ALEXANDER

Culture produces stuff—potentially overlooked yet important stuff to the twenty-six artists in this exhibition. Their subjects are the ordinary items all around us that pile up in garages, attics, yard sales, and storage containers, waiting to be regifted or carted off to the local secondhand shop. Often made or manufactured with the look of the authentic, local, and handmade, this stuff is borrowed, personal, purchased, new, worn out, found, dusty, valuable, lost, worthless, cherished, and perhaps even historic. It comes in many forms, including felt, yarn, plastic, sparkles, ribbons, buttons, and seashells. The practitioners drawn to these objects are collectors, crafters, curators, and, above all, critical interpreters who expose the unexpected visual pleasures of the everyday—the shapes and patterns of the street, or the flow of movement as people make their way through space. More likely, they are drawn to the hidden messages of life's oddities—the eclectic bric-a-brac and unwanted leftovers. Now more than ever, we live in a culture of inherited surplus—some of it interesting and much of it disposable. When it comes to the plenitude of life's castoffs and commodities, artists have never had such a wealth of source material nor such an array of tools with which to process and understand it.

One might dismiss this interest in the commonplace as already established folklore within the history of art. Indeed, since the early twentieth century, many have dipped their hands into quixotic products of material culture, evident in Pablo Picasso's use of toys in his sculpture, Marcel Duchamp's found "fountain," Jackson Pollock's *Full Fathom Five* (full of tacks, cigarettes, and buttons), or Robert Rauschenberg and Jasper Johns' recycling of Soho castoffs (fig 1). Poor art, junk art, low art. And, of course, there are the ubiquitous works of Pop and the man known colloquially as "Andy." No doubt the artists in this exhibition draw from these various moments in art history. But their objects and ideas are distinctive and unique, exploring very particular and peculiar forms of mass culture. In short, they trade in the vernacular. While Andy Warhol wanted to be a "machine" à la mass culture and a manager with his superstars, the artists represented in *The Spectacular of Vernacular* are closer in spirit to those who shop at the corner store, hang out at the local coffee shop, and pursue their curiosities and fancies with devil-may-care independence.

fig 1

THE SPECTACULAR OF VERNACULAR

The subject matter explored in this exhibition is too local and rustic to be called "Pop" and it is too carefully crafted and narrative to be associated with Duchamp's readymade tradition. Rather, the vernacular is something more humble and, significantly, homespun. Even today, it continues to provide enduring images of artifacts made to enhance domestic life. These folksy forms suggesting a world of cozy comforts bear sentimental associations that artists often feel compelled to revise, critique, and upend in ways both humorous and unsettling. For many, the vernacular represents something highly personal, unpredictable, and attached to memories of youth and home, from the objects adorning mantelpieces and walls to the amateur creative expressions found at church fairs and local bazaars.

Many contemporary artists have looked to localized customs and subcultures for their inspiration. There, they have discovered the vernacular as a new kind of found object—derived in large part from a process of homing in on distinctive practices, such as gift-giving and holiday celebrations, amid a broader scope of mass cultural products. They have culled from spoken idioms and regionally or culturally specific qualities of architecture, cuisine, or folk tradition. As consumerism has spread, the vernacular has expanded to commercially produced goods that retain some geographic affinity or idiosyncrasy. Yet even within an expanding marketplace where products look more alike across disparate localities, a number of artists have been drawn to the weathered and worn attributes that make an object unique and give it a feeling of use and history.

In its modesty and familiarity, this kind of subject matter represents something critically desirable at this moment—a connection to the unassuming forms that define what we make as well as how and where we live. The approach of artists in the exhibition could be viewed as singularly grassroots, if not in the attitude underlying the works themselves, then in the heightened sense of physical contact with the world of making things. While some recognize the loss of certain creative skills once passed from one generation to the next, others are happy to see those traditions gone, or at least redefined. At times, their work veers toward nostalgia, occasionally hinting at something belonging to another era.

The works in this exhibition, however, are very much of this generation. These artists look at the vernacular through the lens of global change, commercialization, and the evolution/dissolution of distinct rituals. Some are directed to the qualities of the vernacular that bespeak the particularized appearances of certain places, organized here under the section called "Location, Location, Location." Others convene their content around the vernacular attending certain rites and repeat behaviors, found under "Habits, Rituals, and One Epic." And many explore the subject as a way to address amateurism, a phenomenon that has experienced exponential growth with the rise of the Internet, organized under "Amateur Effect." These categories are necessarily fluid, since what can be seen as an expression of one set of interests

(in nineteenth-century mourning rituals, for example) can depend on another for execution (the current mode of remixing materials and histories). What binds all of these works is the overlay of contemporary art, which, while digitized and networked in the alternate reality of the Web, continues to advance and deepen understandings of a very tangible and locatable existence, borne out in objects derived from the most common fixtures and artifacts of life.

LOCATION, LOCATION, LOCATION

Every place in America has its own weird brand of vernacular—discernible in ways that people dress, decorate their homes (especially around Christmas and Halloween), and self-identify with certain behaviors seen as typical of the area. Dictionary definitions more formally determine the vernacular to be found in the qualities and characteristics of location "expressed in the style of a place, period, or group," be it in the offhand colloquial phrases that mark language belonging to certain regions or the material manifestations of culture that appear there. [2] The vernacular is, in effect, what destinations—be they lived in or visited—offer as markers of identity visible in the character of the buildings and roadside landmarks. Such civic icons can be touchstones for artists, opening up deeper narratives about American culture, especially in regional architecture. Even as vernacular architectural styles migrate from place to place (the New England steeple and Southwestern "faux-dobe" can be found virtually anywhere), buildings inevitably suggest the ways that various populations present and mythologize their local attributes—grounding impressions of place in identifiable structures. These sites of habitation, and the memories and narratives they embody, in turn become fodder for artists who visually and conceptually reinvent and/or preserve their reflected histories.

The media of photography and literature have contributed substantially to understandings of certain places, and in turn promulgate hard to shake images of those sites through time, even as the places themselves change dramatically. Walker Evans ([PG 46]) made enduring photographs of the rural South in the thirties that conveyed the reality and consequences of the Depression on sharecroppers and their townships. His lasting contribution would be to form an indelible picture of the dusty roads and weathered faces of Hale and Tuscaloosa counties in Alabama, and to fashion, more abstractly, a feeling for its sensibilities and qualities from "straight" documentation. To this end, his exploration of vernacular played a pivotal role. It is everywhere in the descriptive clarity of his pictures: the faded posters gracing bedrooms walls, the worn bed linens, and the crisp white clapboard of rural churches. Hardship is visible in the humble structures lining streets and dotting fields, but this is not exactly his subject. Rather it

is how hardship is known through the things people keep and cherish in the places they inhabit, however tenuously. Many of his subjects—especially the buildings—appear worn; some lean precariously to one side, an effect further exaggerated by the frontal approach of Evans' camera. His works are not themselves examples of the vernacular. On the contrary, they are often viewed as examples of a spare, restrained aesthetic of photographic modernism. Yet he tended to the conditions of his subjects carefully, spending time getting to know people before entering their homes. His photographs emit a sense of familiarity because they are so attentive to subtle features and juxtapositions of highly personal yet often unpopulated scenes. Indeed, when his subjects are absent in body, they are present in the relics and effects they leave behind, which become physical stand-ins for a deeper, more psychological portrait of a time.

Evans' photographs produced their own kind of legacy—not only because they envisioned a decidedly dramatic moment in American history, but because their eventual widespread circulation created compelling source material to which others would return. William Christenberry (Pg 43) first discovered Evans' photographs at a Birmingham bookstore in 1959, and from that happenstance encounter formed a deep emotional and artistic bond, reaching out to the older photographer during the last decade of his life. Unlike many fans and some critics who debated the single-minded nature of Evans' view of Depression-era America, Christenberry felt a connection that was both private and specific. Evans had produced many of his most famous images in striking proximity to Christenberry's hometown in Alabama, documenting places and people well known to the younger artist: his great-uncle's country store; the weathered house that was now completely gone; and the churches he said were "painted white, but not necessarily for white people." 03 Thus, what for others served as impersonal and straight-on images by a renowned figure elicited textured memories for Christenberry, and they catalyzed an artistic practice centered on reviving and revisiting those remembrances in new photographic documents and dimensional sculptures. These works, in marked contrast to Evans' appeal to objectivity, are hauntingly composed and crafted, with traces of the Southern landscape itself palpably evident in their warm palette and simple structures. For artists such as Christenberry, the vernacular was both Evans' and his own, something seen and recorded decades earlier and lived real-time on street corners and porches, in shops and at local attractions. Oftentimes artists are first aware of the vernacular as it existed in the landscapes and landmarks of their pasts—in actual buildings they once inhabited. As vernacular studies historian Kingston William Heath has observed, "Place is ... more than a geographically definable entity accentuated by historical and visual landmarks.... On an emotional level, it is a mental construct different for each of us,

and, in the case of childhood dwelling places, tied from youth to personal experience." [04]

Identification with regionally specific buildings of a certain place is just one aspect of Siah Armajani's work, apparent in his freestanding wood sculptures and enclosures that evoke the American vernacular, from the barns, bridges, and houses of colonial New England to the sturdy structures of the Midwest. For the artist, these buildings are the visual vocabulary of a unique nineteenth-century ethos characterized by frugality, simplicity, and community, which he captures in works such as *Closet under Dormer* (1984–1985) ([PG 42]), a piece at once deeply evocative and resolutely modern. Collaging shapes that hint at the influence of Russian Constructivism, an early twentieth-century movement known for its bold and often political designs, Armajani displays a keen awareness of ways that objects function as art-historical prisms and as spaces for social interaction in the present tense; many of his works suggest places to sit, gather, read, and sleep. In some cases, they do so abstractly, forming imagined space out of flat planes and voids. Armajani came to the United States from Tehran in 1960, and has lived in Minneapolis for more than four decades, creating both freestanding works and large-scale public sculptures that include gazebos, reading shelters, and bridges. The Minnesota home base, with its wide expanse of Midwestern landscape to traverse, intense weather to brave, and long vistas to take in or interrupt, seems aptly suited to these structures.

Such artists do not make art about place but within it, immersing themselves in the lived lore and artistic traditions of locales that sometimes feel frozen in time. Aaron Spangler ([FIG 2], [PG 44-45]), who has resided in New York and was raised in rural Minnesota, makes autonomous sculptural objects that tap a dense field of aesthetic references, from the dark, totemlike constructions of Louise Nevelson to American Regionalism à la Grant Wood. Yet these various points of reference seem somehow to converge around the reality of living in a remote location where survival is a complex negotiation of adapting to the elements and managing a degree of social isolation, experiences that together inform the subtle layers of Spangler's chiseled forms. His wooden sculptures allow a constellation of seemingly disparate iconographies to meld into one: guns and other machine parts, haystacks, and wildlife converge in intricately carved scenes that stand on abstract bases. These objects could derive from anywhere, but they also lay claim to the unique set of circumstances surrounding Spangler's direct experience of rural life. By incorporating overt references to a vernacular steeped in the Midwestern landscape, Spangler confronts and repurposes the inherited symbols of this terrain, reshaping its contexts and accentuating its narratives. If the vernacular can be found in the unusual outcroppings and structures that characterize certain places, it proposes a specific vocabulary that artists can translate and condition with their own interests and organizational strategies. What Spangler

Aaron Spangler Installation view of *Government Whore* 2010

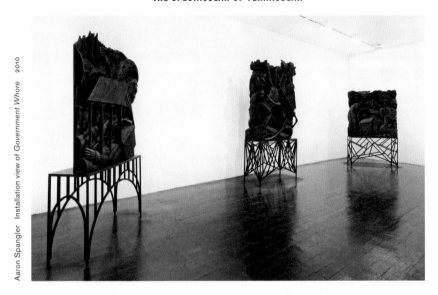

^{FIG} 2

constructs is an assemblage of such forms, which takes on a deeply reflective and occasionally sinister subtext when brought together in his particular way.

The extent to which the appropriation of the vernacular points back to the themes and ideologies of certain places varies considerably; artists are in the business of importing motifs, and they use them to address broader issues that apply to culture or society at large. Oftentimes their forms distill features that look vernacular, or hint at a method of construction that evokes old buildings and rural outposts built to stand up against the elements. For Chris Larson, the landscape of the Midwest is one of the imagination, flat and wide enough to hold his ambitious and extravagantly constructed installations. Much of his work, when it takes the form of three-dimensional sculpture, resembles bizarre, cobbled-together farm equipment that is simultaneously futuristic and technologically outmoded. Humans try to harness these behemoth machines, only to be harnessed by them. In the video *Deep North* (2008) (^{FIG} 3, ^{PG} 80-81), several women push frozen gears and knobs in an iced-over cabin stuck in the middle of nowhere. In *Bogus Brook Township* (2002), a man (in this case, the artist) is held captive in a chair that evokes a nineteenth-century torture chamber. To these colliding and comingling references Larson brings a fierce form of carpentry—sawing, slapping, and bolting parts together to fashion forms that look and sometimes *are* utilitarian and that possess a rough-hewn quality often strikingly at odds with the streamlined order of many institutional settings in which they are exhibited. His work gently upsets the aesthetic balance of these sites, playfully introducing his visual non sequiturs where they most belong.

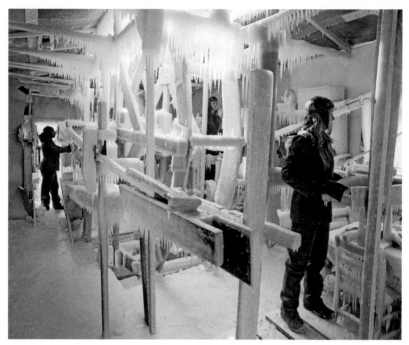

Chris Larson *Deep North* 2008

^Fɪɢ 3

In part, a tension is formed by the urbane quality of the art establish-ment and the folksy, often out-of-date look of Larson's brand of the ver-nacular when it is reimagined for this context. Indeed, for some contem-porary artists, what most appeals about the vernacular is its evocation of rusticity or rurality, a theme that has emerged again in recent years. Increasingly, individuals and artists' collectives are exploring the idea of the outdoors as a democratic common ground, one among many plat-forms that offers a model for public space, skill-sharing, open exchange, and group production; often their sites involve temporary environments built from scratch, including ad hoc shelters and dramatic handmade road signs designed to grab the attention of drivers. (^Fɪɢ 4)

Others take a critical view of these communally inspired endeavors, highlighting instead the idea that rural life and its attendant vernaculars have been romanticized by those seeking exile from urban discomforts and material excess. Fantasies of countryside purity fade into more men-acing narratives of the backwater in works that, by contrast, tap deep-seated fears about living off the grid in a relative isolation that can breed its own extremism. For an artist such as Matthew Day Jackson, the notion of rural communal life has one unforgettable icon: the Reverend Jim Jones' Peoples Temple settlement at Jonestown, Guyana, where in 1978, more than 900 people died in a mass murder-suicide. Images from the day remain among the most horrific of the post-Vietnam years, and Jackson taps them in *November 18, 1978* (^Pɢ 48-49). He depends on the

collective register of this familiar event for a particular generation (the artist himself was born in 1974), unraveling its graphic content, twisting its details, rendering it colorful and disconcertingly domestic—not at all what one would expect of a murder scene, and for that reason, all the more potent.

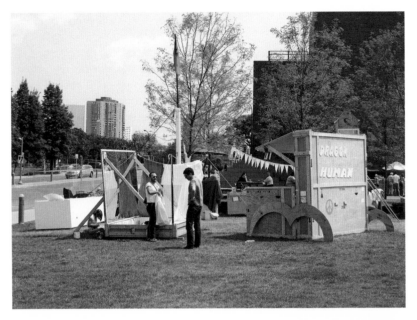

Red76 Collective at Open Field, Walker Art Center, summer 2010

_{FIG} 4

If in its embodiment of the material residue of certain places—the buildings and handicraft, landmarks and eyesores—the vernacular captures the stories and aesthetics of common culture, it is typically the task of artists to set those stories off-kilter—to displace original context and meaning. As American art and cultural critic Dave Hickey has observed, "How ... does a work of art in a cosmopolitan, historical tradition like our own express its 'local history' and its 'sense of place' when, within this tradition, the 'true subject' of the work is nearly always presumed to be occluded and displaced?" [5] Today, many artist are bringing forward highly individualized references to culture and place, often within the sprawling contexts of international art fairs and biennials. Perusing such sites of potential displacement is increasingly a matter of seeing, often side by side, an accumulation of artworks that emphasize locality in different ways—often to accentuate the particulars of language and communication, to expose discernible traits of specific environments and communities, or to reconstitute forgotten histories within a larger contemporary narrative. As the tentacles of art expand to embrace and contextualize such works, the nature of "local" becomes permeable and more susceptible to influence or change. For the artists addressing this subject here, the sense of local engages the most subjective of experiences, tapping private histories, backgrounds, and a longing to find or escape the "where" of one's youth.

HABITS, RITUALS, ᴬᴺᴅ ONE EPIC

Among the standout features of many artists exploring the vernacular is a sustained connection to the way objects function within everyday ritual forms that vary between cultures and regions. For the most part, examples made in this exhibition foreground American ritual, with one notable exception: Marina Abramović's *Balkan Erotic Epic: Exterior Part 1 (B)* (2005) (PG 76-77). Known for her live performances that test the physical and psychological endurance of participants through encounters that can be emotionally or sexually charged, the artist here makes a production for video based on ancient pagan customs, in which amateur actors perform eroticized bodily gestures in the open landscape, fully outfitted in folk costume. According to Abramović, "If there was too much rain, the women from the village would run into the fields and lift their skirts and flash ... the gods to scare them. So I went to Yugoslavia and talked perfectly ordinary women from the village between the ages of 18 and 75 into doing it." [6] They were extremely enthusiastic, and the artist successfully transformed her research project into an engaging, at times hilarious, presentation. In fact, what becomes as visible as the bizarre tradition itself is how the act of re-creating it becomes its own kind of ecstatic religion, albeit one of performing—in this case, in front of the camera. This has been

Jim Shaw Selection from Paintings Found in Oist Thrift Store (Fantasy Oism) 2007

Fɪɢ 5

well-trodden turf for Abramović, who has reenacted many of her sev-enties-era performances to sellout crowds. Her ritual thus operates on two simultaneous levels: the first is tied to the researched vernacular customs of an ancient Serbian society, and the second to a highly con-ceived, if not fully orchestrated outdoor action. In all of these overlays of folk and art, a specific vernacular and pagan source material is clev-erly leveraged to introduce themes of "tradition" and worship into the critical sphere of contemporary art, where normative values and belief systems are routinely interrogated.

 Jim Shaw, known principally as a painter and sculptor, has been obsessed with the vernacular of religion since the late seventies. He

was drawn especially to the expressive value of paraphernalia–from broadsides to Sunday-school brochures to biblical renderings–and the ways such materials provide a profound register of American taste, class, and personal preoccupation. In the late nineties, he conceived of a fake form of Christianity called Oism, which continues to inspire within his work a lavish alternate reality of objects, stories, and characters. Glimpses into the ethos and habits of the pseudo-cult are formed in Shaw's fictitious underpinnings; he makes paintings and movie posters that are ostensibly the work of Oist acolytes. *Paintings Found in Oist Thrift Store (Fantasy Oism)* (2007) (Fig 5, PG 84-85) and *Paintings Found in Oist Thrift Store (Present)* (2008) (PG 86-87), for example, are contrived to resemble the efforts of self-taught artists overtaken by belief (and nightmare, as the works would suggest). The paintings in turn reference "real" amateur works, such as those in a series known as *The Thrift Store Paintings* (1974–2008), which is made up of a vast collection of works by untrained artists that Shaw assembled. These pictures of children, flowers, and pets range from the flagrantly eccentric to the absurdly familiar. "I don't know why they were made," Shaw says. "I can only conjecture what was going through the heads of the people [who] made them. So that puts me in the same position as anybody else looking at them." [7] In the new *Oist* painting series, Shaw must imagine what fictional devotees would make under the spell of their religion. Why do people make stuff as they do, and why does it seem to fall into specific patterns? It doesn't matter that Shaw moves from faith to comic books to dream sequences to sci-fi television shows for inspiration. He appears to be pursuing not only the objects of ritual but the ritual of making objects, and many of them convey parallel messages even as they come from radically different worlds.

Mike Kelley's art looks utterly conditioned by what he sees in popular culture, yet from the outset his practice has examined aspects of middle-class suburbia and its habituated behaviors. He continues to draw ideas from the "performative structures" of children's plays, marching bands, Christmas pageants, and dress-up days, relying heavily on high school yearbooks, which he says are "really the only place where I could get pictures of these kinds of common American folk rituals." [8] Within a cluster of themes that addresses adolescence and childhood, Kelley also explores the customs of home life, including gift-giving and, more broadly, "do-gooder" culture, by which he means the seemingly generous practice of bestowing objects that can never be repaid upon others. His plush toy projects, for example, which came about in the late eighties, examine the relationship of handcrafted items to a process of social and personal one-upmanship. In the large scale installation piece *Craft Morphology Flow Chart* (1991) (Fig 6), toys lie on flat card tables, organized into a kind of genealogy. At around the same time, he made *More Love Hours Than Can Ever Be Repaid* and *The Wages of Sin*

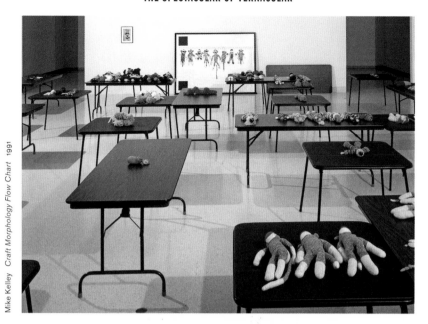

Mike Kelley Craft Morphology Flow Chart 1991

Fig 6

(both 1987) (Pg 92-93), an assemblage of afghans and soft toys whose title is an indictment of the guilt-infused act of giving homemade, labor-intensive items to a recipient who translates the adage "time is money" in unsettling terms. Under these conditions, an object that represents a sign of love for one becomes a burden for another—and possibly winds up at the back of a closet.

It's difficult to sidestep the observation that many artists seem drawn to the absurdist properties of rituals and the regulated modes of behavior they appear to reinforce. As some have observed, even Halloween pageants and carnivals—occasions designed for role-playing—are in fact orchestrated to provide an unthreatening time and space for mildly aberrant behavior. For artists, the vernacular accoutrements attending such activities open an invitation to wrongly, ironically, and humorously "interpret" its meaning and symbolism. The stag head that Marc Swanson puts on an aesthetic mantelpiece is not the kind found in rustic lodges where boyhood rituals of camping and hunting are played out, but the glittering sort envisioned by a gay male. In Swanson's version, a rhinestone-encrusted deer turns its gaze to the wall, exposing a neck whose shimmering shaft evokes disco balls and nightclub décor, inflecting the woodsy icon with an urbane, erotic veneer. Here the artist makes sense of a familiar childhood recollection (he hunted and fished with his father) by giving this trophy a new set of references to counteract the ones he inherited.

In a similar vein, Jeffrey Vallance fashions work that appropriates the look of a familiar scene to narrate his own offbeat story. On the surface,

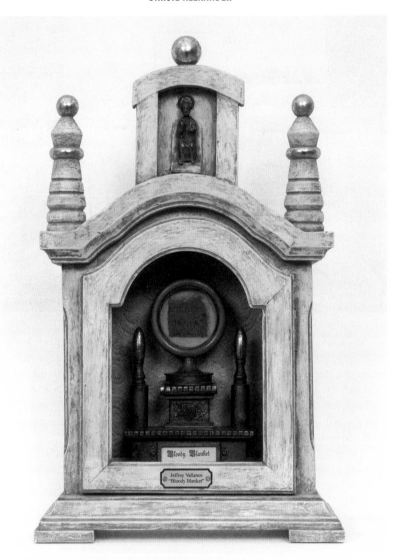

^{Fig} 7

Jeffrey Vallance Bloody Blanket (Performance Relic) 2006

his pieces resemble roadside reliquaries and church memorials, but the content and language is decidedly more profane. (^{Fig} 7 , ^{Pg} 82-83) In his gorgeous glass cabinets he places an assortment of impromptu discoveries, cherished objects, and highway junk, often with personal "explanations" attending their display. In two related projects, the artist dovetails an exploration of Christian iconography with themes pertaining to his own identity. As one critic has noted, "His thorough, if quickly documented, re-creations of the Lance of Longinus (which pierced Christ's side after

he died on the Cross), and the Veil of Veronica (on which a portrait of Jesus was printed when she wiped his face on the way to Calgary) chart a rich history interwoven with myth. At the same time, these holy relics spell out the artist's name: run together, 'veil' and 'lance' sound suspiciously like 'Vallance.' " [9]

The insertion of an artist's personal narrative into stories alongside histories belonging to others is a subtext found in the work of Dario Robleto ([6] 94-95), which often centers on themes of personal loss and the memorial. The industry and rites surrounding death in modern society are among the most pervasive, if least discussed, venues for vernacular objects, from ceremonial flags to family photos documenting the deceased. Many of these appear in or subtly inflect Robleto's practice. He situates his work in visible dialogue with these traditions, stepping out of time to tap nineteenth-century mourning customs that today feel both quaint and distant. Positing that "an artist has to remember while others forget," he infuses his art with a sense of personal responsibility and a willingness to position his efforts on a longer continuum of nameless makers whose contributions are typically forgotten: the seamstresses and mothers who prepare memorial wreaths, burial attire, and braided hair flowers upon the deaths of loved ones, for example. [10] Using an assortment of materials ranging from bullets found on the battlefield to vinyl records (he is also a voracious consumer and spinner of music, and sees much of his work as a form of sampling), Robleto revisits and refashions acts of personal healing through a laborious and craft-based process, learning skills that were once passed from parent to child. In another era, his works would be called "labors of love," but today they must be regarded as a tribute to a form of vernacular that has virtually disappeared. When Robleto combs through old letters and manuscripts on art-making reconnaissance, he revives the lost stories and material vestiges of a bygone era, imbuing them with present-day relevance and continuity.

Repeat behaviors and recurring traditions produce a wealth of made-for-the-occasion objects that constitute an important facet of the vernacular when it operates within discrete personal relationships or religious customs. In some ways, understanding the vernacular to be the offspring of lay culture at large is to accept that it often extends entrenched values, which can in turn be contained in objects that reflect prevailing beliefs, class, and social standing. What is striking then about the vernacular is how well it enables established modes of conduct to be perpetuated—hence its frequent association with tradition, simplicity, and craftsmanship. Artists are sometimes resistant to such assimilation, producing their work to expose the perversity of what is taken for granted in culture while keenly identifying their place within it. If the vernacular affirms the comforts of the familiar, the art it inspires is often conceived to do just the opposite.

DARSIE ALEXANDER

AMATEUR EFFECT

The association of the vernacular with homemade modes of creativity, from knitting to scrapbooking to sketching, is perhaps the strongest characteristic of the term in everyday parlance, and among the features artists singularly explore. Like language, the vernacular can be dialectic, casual, and shorthand—in many ways an appropriate set of qualities for artists who have come of age since the seventies and explored the lines between their own practices and more widespread creative expressions undertaken by society at large, often during its leisure time.

Artists have long gravitated to the adaptive and informal aspects of the vernacular, including but not limited to art that could be made, quite literally, at the kitchen table. The seventies were years of great opportunity, as gates appeared to be widening for work that was impermanent, idea-based, or identified with sectors normally associated with amateurism and industry. For years prior, of course, the modest handicrafts emanating from most American households had no official place in canons of fine art, as they were seemingly at odds with the requisite skills and rigor the designation assumed. It took time and vigilance for these assumptions to be modified and rewritten. In large part, the persistence of activist artists such as Faith Ringgold challenged the outmoded and often male-dominated hierarchies of the art world and fueled a general reevaluation of art's terms and different but equal conditions.

An assertive questioning of the traditional values bestowed upon "great" art came from the feminist sector. Ringgold posed a blunt and provocative question to her peers: "What would you do as a woman in your art, if you could do anything you wanted to do ... [and] you were just looking within yourself...; look[ing] at what women did ... when they were just working, and doing something creative, and not having the posture of, 'Hey, I'm an artist.'" [1] Ringgold herself appeared not to have been impeded by such concerns, and embraced what others may have seen as marginalized "feminine" expressions as an integral foundation of her practice, specifically as it incorporated quilting, a longtime tradition in her family. On reflection, her approach was one that sought to affirm and acknowledge women's artistic heritage while critiquing the networks and classification systems that rendered them peripheral. Even as the boundaries between strata blurred and artists such as Claes Oldenburg (fig 8) and Robert Morris regularly employed sewn fabric and felt to construct their pieces, the work of some feminists using techniques such as crochet and needlework came to the fore during the peak years of Minimalism and conceptualism, movements that adamantly rejected "the arbitrary, the capricious, and the subjective." [2] Under such circumstances, rupturing dominant practice was easier said than done; even some feminists resented an approach that privi-

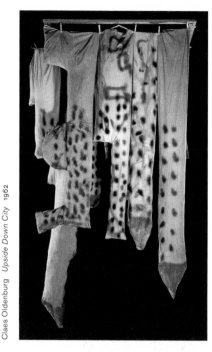

Claes Oldenburg *Upside Down City* 1962

ᶠ¹ᴳ **8**

leged "the anonymous toil of un-known women" when they them-selves could not find outlets in the art world or ready employment. ¹ᴊ Others insisted on retaining, rath-er than suppressing, a gendered approach to art as a form of per-sonal agency and empowerment that also aligned with the goals of civil rights.

Decades have passed since debates about distinctions such as art/craft and amateur/professional were first presented and contested, and today few artists who show their work in museums or galleries would feel impeded by the use of materials traditionally associated with spheres outside art. On the contrary, contemporary art is noth-ing if not omnivorous, absorbing all varieties of material culture into its evolving matrix. Incorporating the work of amateurs and unprofessional peers within one's own work is increasingly regarded as a means to open the field of art to collective ideas and responsibility, a form of exchange that now sees an influx of user-generated content circulating online. The integration of other voices and practices, some of which may not "belong" to art, into a spectrum of a single artist's vocabulary and subjectivity is a notable trend that gives new texture to the histories of assemblage and appropriation.

With vast repositories of cultural detritus now readily acces-sible through the Internet and eBay, engaging its content is as much about editing as it is about producing new and multifaceted objects with what is found. Lorna Simpson (ᴾᴳ **90-91**) trolled online sites for a selection of photographs that embody much of what the vernacular offers: a glimpse into the rituals of other people's lives expressed in their castoffs. For a recent project, she found snapshots of an anony-mous young woman taken at her home in the Los Angeles suburbs during the fifties. Simpson uses these images as the basis for her own restagings and in uncannily similar gestures reenacts the woman's poses, eventually placing the pictures in small clipped frames ar-ranged in close proximity to each other. The results—one posed in the context of private life and the other in the context of an artistic practice that has always involved a degree of performance—are strik-ingly different. Photography's complex mirroring effects are visible not only in the two women who resemble one another but in the amateur

snapshot appearing as art. For Simpson, the vernacular in question is highly personal, originated for reasons the artist can only imagine. As a result, viewers must imagine, too, and address the terms of their own interpretive response as it yields narratives, hypotheses, and assumptions about why people feel the urge to produce their own form of visual culture.

Kara Walker's cut-paper silhouettes are derived from a nineteenth-century parlor pastime for well-heeled ladies and gentlemen, wherein likenesses were rendered with scissors in the quiet enclave of the home. (ᶠⁱᴳ 9, ᴾᴳ 64-65) It is hard to project just which aspect of the silhouette might have appealed to Walker the most: the loaded references to class, the connection to antebellum-era racism, or the form's attachment to shadows and darkness visible only through outlines. It is Walker's task as an artist to give those outlines depth and complexity, and she does so by stripping away pictorial niceties to reveal something more sordid and unsettling. Frequently executed directly on the wall and occasionally drawing upon such sources as *Harper's Pictorial History of the Civil War*, her scenes are dramatic and bizarre, filled with sexual perversity, exaggerated physiognomies, and rampant conflict. There is no easy way to sum up any one of Walker's works, composed as they are of multiple vignettes and storylines, but they are cut with a surgeon's precision, leaving in as much as is needed and excising the rest, forcing viewers to project their own narratives into the empty spaces of her work.

ᶠⁱᴳ 9

Kara Walker Selection from *Harper's Pictorial History of the Civil War (Annotated)* 2005

Walker's practice, like others in this exhibition, draws upon the cultural associations of common vernacular. She has noted that she is attracted to genres, and we can observe in her work that they extend beyond silhouette to encompass black memorabilia, romance novels, folklore, and cartoons—what others may describe as "exaggeration genres." For an artist such as Laura Owens, on the other hand, the past is a place full of quiet makers and modest efforts. Much of her work centers on the anonymous females—the sample-makers and fairytale illustrators who sewed, stitched, and painted. Owens refrains from overly explicit references, however; her loose and airy paintings are also imaginary, seeming to suggest the dreams of these girls as much as their handiwork. The reference to sentiment—indeed emotion—is everywhere apparent in her work, as is a visceral and unabated optimism

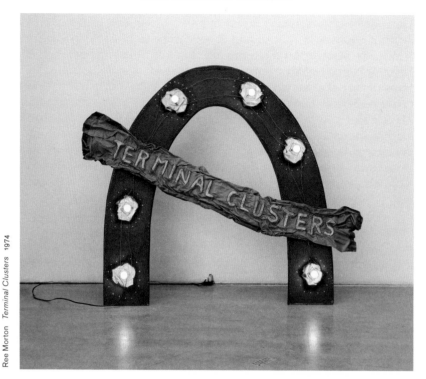

Ree Morton *Terminal Clusters* 1974

ᶠⁱᵍ **10**

conveyed by her images. In this respect and others, she sustains qualities of both openness and intimacy that can likewise be found in the art of Ree Morton, who emerged a generation earlier. Morton's works, including sculptural wall reliefs and freestanding objects, willfully derived their content from the domestic sphere and personal relationships centered on friends and family. (ᶠⁱᵍ **10**, ᴾᵍ **62-63**) As curators Allan Schwartzman and Kathleen Thomas observed in a retrospective monograph published several years after the artist's untimely death, "Morton's words are effusive, reflecting a playful nostalgia for the kind of emblematic clichés found on dime-store plaques based on early American samplers of the 'Home Sweet Home' variety. Their hackneyed flavor is tempered by a homespun freshness, a flare for decoration, the logic of practicality, and a hint of the foreboding." ¹⁴

Insofar as Owens and Morton make work that dips into the realm of fantasy and personal memory—referencing the sentimental touches of home, from its decorative flourishes to personal ephemera—they play upon the commemorative value of some forms of the vernacular. In a similar vein, though through strikingly different formal means, Kerry James Marshall honors and reimagines the deeds of famous as well as fictional black protagonists in dramatic figurative compositions that often suggest a living-room portrait or souvenir on a grand scale.

Composed of overlapping layers of paint, glitter, and text, the works present aspects of African and American history, amplifying and affirming its place in art more broadly. In *Gulf Stream* (2003) (ᴾᴳ **88-89**), he re-creates an 1889 painting by Winslow Homer of the same title, transforming the menacing tenor of the original with an undeniably positive—indeed bucolic—replacement. In Homer's version, a single black sailor navigates treacherous, shark-infested waters. Marshall's work, surrounded by a faux-nautical border, shows a relaxed group, possibly a family, out for an afternoon sail with a backdrop of blue skies and seagulls flying overhead. Marshall turns the drama of Homer's stormy scene into one of pleasure and relaxation, with barely a cloud on the horizon.

Vernacular source material establishes various opportunities for artists to connect with the work of amateurs, craftspeople, and tradesmen whose creative motivations run across a wide spectrum of histories and experiences, and it is a springboard for strong critical dialogue that exposes one of the most pervasive features of vernacular artifacts—their anonymity. For many artists, the vernacular is something left over from someone else's past that exists in objects flowing into the present by way of the Internet, estate sales, and hand-me-downs. As the byproducts of unknown creators whose histories are often inaccessible, such orphaned cultural artifacts are open to dynamic recontextualization as inherited features are highlighted, exposed, or dramatically erased. While examples of all can be found in these pages, the question of artists' relationships to the unknown—specifically unknown makers—bubbles beneath the surface of any conversation concerning the vernacular, as its themes and manifestations are fully revisioned from contemporary vantage points and inflected by the stories and preoccupations of these times.

ᴛʜᴇ "NEW" VERNACULAR

How could such a folksy vernacular, seemingly defined by modesty and homespun sensibilities, owe any allegiance to notions of spectacle? The answer rests in ways that definitions of the term have changed in the field of cultural studies since the seventies as the landscape of urban America dramatically shifted to encompass the rise of residential developments, billboard advertising, and strip malls. This delivered what critic John Chase called "the unvernacular vernacular," an architecture formed not on indigenous building techniques and lay construction but on manufactured destinations made for cars and highways. ⁵ For many years, vernacular was meant for something more significant and original, something inflected by human hands. In 1972, with the publication of *Learning from Las Vegas*, Robert Venturi's groundbreaking collaboration with Denise Scott Brown and Steven Izenour, all that changed. Vernacular had a new cause in the

billboards, sprawling casinos, and drive-in theaters of the strip, where the cacophony of commerce animated the desert, transforming it into a carnival of flashing lights and ornate building facades. In strong defense of this "ugly and ordinary" architecture, Venturi, Scott Brown, and Izenour argued for what had long been derided: the complex ornamentalism of false fronts and overblown street symbols. An obsession with vernacular models that were "popular where advanced technology is, even for Modern architects, farfetched" had run its course, and contemporary life simply demanded new building forms that could accommodate a love of tourism and dependency on cars. [16] This vernacular didn't have the patina of age and tradition that had defined older, "primitive" (and extinct) models, but it was no less an outgrowth of distinctive cultural patterns and behaviors of society. In contrast to past definitions, however, it was decidedly loud, visually pervasive, and dominantly commercial.

Expanding the terms of vernacular to reflect the reality of commerce brought a new appreciation for and critical investigation of the overlay of signs and meaning that one could find on America's streets. Part of this investigation played into the work of an evolving mix of photographers such as Stephen Shore and William Eggleston (PG 52-55), who during the seventies took pictures on the road using new color formats that gave subjects the unprecedented chromatic platform now synonymous with the era. As early as 1966, artists such as Ed Ruscha examined the street as a linear order of visual facts to be systematically documented without coloristic inflection; his self-published accordion-style book *Every Building on the Sunset Strip* is, by contrast, deliberately flat-footed and non-narrative, reflecting a nascent interest in photography as an extension of an idea-based conceptual practice. However disparate, these artists exposed the embrace of a street vernacular that had deep roots in photography's history, and upped the ante, giving form to the vast array of discordant sights and subject matter filling the landscape then and even more densely today.

To experience Rachel Harrison's *Voyage of the Beagle, Three* (2007) (PG 74-75), for example, is to acknowledge the coexistence of a strikingly diverse and hilariously incongruous visual reality. Recording her found iconography with a camera, Harrison takes pictures that document what might be called contemporary monuments, but they are of an undeniably humble order; storefront mannequins and taxidermic bears come up against "fine art" objects and religious reliquaries. Between these randomly encountered subjects, her thematic adhesive is the inanimate human face, whether carved from rock or embalmed in plastic. In some respects, the project is a typology, the artist's own "origin of the species" for figurative sculpture (the title references Charles Darwin's 1831–1836 expedition on the *HMS Beagle*). Yet her series also alludes to the visual jumble filling the pages of magazines, the shelves of department stores, and the sidewalks of

a very current world that calls for the particularly pluralist approach characterizing much of the art in this exhibition.

The terms set by such thinkers as Venturi, Scott Brown, and Izenour created a platform for others to take seriously the aesthetics of a new visual reality—one filled with mass-produced junk, over-the-top signage, and flash. It was a visual reality that, as Andy Sturdevant argues later in this volume, found special accommodation in the landscapes of the Midwest and West, where open plains and desert emptiness demanded orientation and scenery, sparking a profound urge on the part of businesses, architects, and engineers to populate and decorate. The filler they made signaled to some a dreaded over-run of nature, a wasteland of incongruous building types and blistering parking lots. Others took a more welcoming view, finding a rich new vocabulary of material culture in roadside attractions and motel signs. Artists have long displayed an affinity for such themes and subject matter—Surrealists of the twenties and thirties, for example, were drawn to the juxtapositions of flat surfaces and oblique messages delivered by posters, advertisements, and storefront windows. Today artists more frequently interrogate ways that products and experiences are bought and sold in the media, yet often fail to achieve their desired effect amid a sensorial hyperreality of abundant merchandise and screeching sales appeals.

"HEY GIRL, LOVE-SEXI! CUM N' GIT IT!" cries Lari Pittman's *A Decorated Chronology of Insistence and Resignation #30* (1994) (P₆ 96-97), beckoning with its barrage of colors and slogans a spectrum of services to be bought and bartered—brought to you by two ubiqui-tous credit card companies whose logos appear on the margins of the canvas like discreetly placed cash-register decals. In this sales world, however, nothing is discreet, least of all the art. Pittman's works are tes-taments to the power of the ornamental, or what he would term "junky secularism." Since the eighties, he has synthesized kaleidoscopic references in his work, from Victorian silhouettes to carnival placards and space-age automobiles. In this respect his work stands in striking contrast to the reductivist tendencies of Minimalism; it is feverishly ani-mated, full of jump-start narratives and dense pictorial layers. A collage mentality is at work here, with signs poking up from all directions, just as they do on the highways outside of his home in California.

The open expanse of desert that surrounds places such as Las Vegas and Los Angeles is a tabula rasa for signage vernacular that forms its own brand of roadside eclecticism. Artists have long been attracted to both the abstract qualities of words in the landscape and the often-beleaguered look of the signs themselves, coming at the subject from various positions of critique, nostalgia, and vi-sual interest. Certainly this theme emerges in work by Shannon Ebner (P₆ 56-59), a photographer who deals explicitly with the idea of percep-tual orientation in pictures that evoke the experience of driving through

the West, looking for landmarks and guideposts on a long road trip. Rather than myriad stop signs and billboards, however, one encounters something rather more spare and humble in her frames—handmade texts made of plywood and sandbags that the artist has placed out on the horizon and precariously balanced against wind and rain, akin to the HOLLYWOOD sign perched atop Mount Lee in Los Angeles, with its old scars and outmoded structural supports. Ebner's letterforms, however, are nondirectional, forcing the land and its language to be deciphered in fleeting glimpses. In a similar way, Jack Pierson's works, appropriated from fragments of vintage signage assembled to form words or phrases, promote a pieced-together form of reading, albeit in sculptural terms. Loaded words such as "Beauty" or "Desire/Despair" become his own form of concrete poetry, at once spatial and linguistic. Pierson's language is typically simple and evocative, transforming the brash messages and bright colors one associates with drive-in theaters and motels into lyrical and occasionally melancholic reflections.

The crush and clash of material culture that constitutes the subject matter of many works in this exhibition can at times border on the tawdry and carnivalesque, capturing the visual inundation that is so much a part of contemporary reality. How can aspects of culture remain differentiated within such a vast space of exchange? This is, in a sense, a critical question surrounding artists' investment in and critique of the vernacular when matters of place identity, regionalism, and craft arise. If the vernacular can serve as a subject, it frames this question: why, at such a time of fluid exchange and global currency, does it seem relevant to again connect art with these themes emanating from modest sources and down-home spheres? Now more than ever, artists have a constant stream of source material coursing through their laptop screens, television sets, and daily lives. Indeed, in the era of big box stores and multiplexes there appears to be more of everything, especially when it comes to what can be purchased and/or inherited. Yet amid this seemingly endless material landscape, artists continue to embrace culture's unpredictable, idiosyncratic twists and turns, even as other aspects of life are being shared across expansive networks. Why is this? Some critics assert that social media and the Internet have produced an abundance of niche markets from which individuals—especially artists—seek to distance themselves. In many respects, this is something artists have always practiced—differentiating what they make or conceive from everything else around it, "an everything else that is growing and growing." [17] As Mike Kelley once remarked, "Art is the only place where you can be truly weird." [18]

It is also, for many, a place to be truly critical of the seemingly innocuous objects that adorn ever day life yet are deeply inscribed. A final example can be made of William E. Jones' *Killed* (2009) ([Fig 11], [PG 66-69]), a moving-image work composed of pictures that were sequestered in a library for seventy years. These images were rejects, cut from the

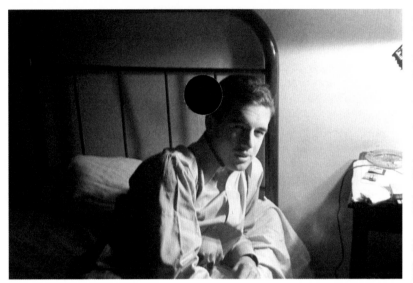

William E. Jones Still from *Killed* 2009 Source image *Washington, D.C.,* December 1937, by John Vachon

Fig 11

Farm Security Administration's photography pool. Deemed unworthy of publication by editors, each was destroyed by a hole-punch in the negative. As one picture gives way to the next in Jones' film, he leaves the viewer to speculate on what is "wrong" within each frame. Was the shot too grainy, the embrace too erotic, the moment too trivial? The questions, while specific to a single work, are akin to those that artists bring to their scrutiny of the vernacular in general. If the vernacular is "of a place" and "of a people," what are the right places, and who are the right people? For the artists in this exhibition, art can be found in the castoffs and the outtakes. Unknown meanings and lost histories can be found there too, shedding a new light on the most familiar assumptions about culture.

NOTES

[0.1]
Mike Kelley, *Minor Histories: Statements, Conversations, Proposals*, John C. Welchman, ed. (Cambridge and London: MIT Press, 2004), 48.

[0.2]
Webster's Third International Dictionary of the English Language (Springfield, MA: Merriam-Webster, Inc., 1993). Webster's gives an unabridged definition of the vernacular, leading with "using a language or dialect native to a region or country rather than a literary, cultured, or foreign language," and carrying through to "a style of artistic or technical and esp. architectural expression employing the commonest forms, materials, and decorations or a place, period, or group."

[0.3]
Benjamin Forgey, "Roadside Glories: William Christenberry Finds an Expressionist Paradise in Hale County," in *Aperture* 81 (1979): 41, 47, 45.

[0.4]
Kingston William Heath, "Assessing Regional Identity Amidst Change: The Role of the Vernacular Studies," in *Perspectives in Vernacular Architecture* 13, no. 2 (2006–2007): 83.

[0.5]
Dave Hickey, "A New World Every Day," in *About Places*, Madeleine Grynsztejn, ed. (Chicago: Art Institute of Chicago, 1995), 54.

[0.6]
Marina Abramović quoted in Jörg Heiser, "Do It Again," in *Frieze* 94 (October 2005): 176–183.

[0.7]
Jim Shaw, "Here Comes Everybody," in *Mike Kelley: Interviews, Conversations, and Chit-Chat (1986–2004)*, John C. Welchman, ed. (Dijon and Zurich: JRP Ringier and Les Presses du reel, 2005), 180.

[0.8]
Mike Kelley interview in "Day Is Done" from the video documentary *Art:21–Art in the Twenty-First Century*, season three (New York: PBS, 2005).

[0.9]
David Pagel, "Jeffrey Vallance," in *Frieze* 23 (June–August 1995): 66.

[0.10]
Dario Robleto, telephone interview with the author, May 20, 2010.

[1.1]
Elissa Auther, *String, Felt, and Thread: The Hierarchy of Art and Craft in American Art* (Minneapolis, MN: University of Minnesota Press, 2010), 100.

[1.2]
Sol LeWitt quoted in *Bits & Pieces Put Together to Present a Semblance of a Whole: Walker Art Center Collections* (Minneapolis, MN: Walker Art Center, 2005), 346.

[1.3]
The phrase is extracted from a letter submitted by the editorial group of the feminist journal *Heresies*, and republished in Auther, *String, Felt, and Thread: The Hierarchy of Art and Craft in American Art*, 99.

[1.4]
Allan Schwartzman and Kathleen Thomas, "Ree Morton: A Critical Overview," in *Ree Morton: Retrospective 1971–1977* (New York: New Museum, 1980), 49.

[1.5]
See John Chase, "The Unvernacular Vernacular," in *Design Quarterly* 131 (1986). As Chase notes, "Commercial vernacular is part of our economic and social evolution and is tied to changes in public taste and living patterns. What makes its study so confusing is that this vernacular seems so unvernacular."

[1.6]
Robert Venturi, Denise Scott Brown, and Steven Izenour, *Learning from Las Vegas* (Cambridge and London: MIT Press, 1972), 103.

[1.7]
For more consideration of this topic, see Michael Kimmelman, "D.I.Y. Culture," *New York Times*, April 18, 2010.

[1.8]
Mike Kelley in conversation with the author, March 16, 2010. The topic of discussion delved into rituals of school life that disallow truly aberrant behavior and art's relative space of freedom and creativity for children.

ART Is THE ONLY PLACE WHERE YOU CAN BE TRULY WEIRD.

—MIKE KELLEY [18]

PLATES

SIAH ARMAJANI

My immediate architectural environment was farmhouses, barns, grain elevators, silos and so on. The peculiar quality of these structures is that once you walk inside and around them you know exactly how and why they were put together. Everything is self-evident. Erich Mendelsohn and Le Corbusier were also fascinated by rural American architecture; these structures were precursors to the Modern movement. So I started taking pieces from these buildings and putting them together. It was a nonfunctional architecture that retained the appearance and statement of architecture. –Siah Armajani, 2009

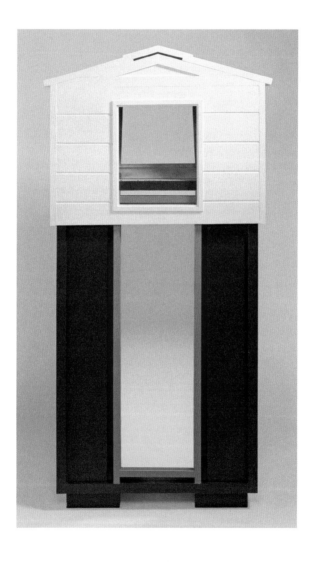

Closet under Dormer 1984–1985
wood, paint, shellac, mirror

WILLIAM CHRISTENBERRY

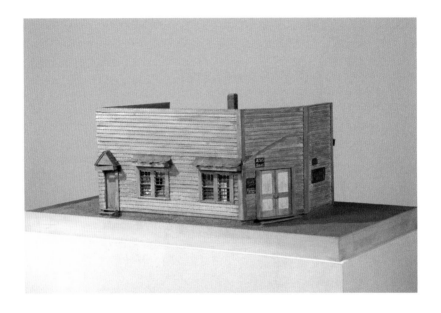

Palmist Building 1979
bass and balsa woods, paper, metal, paint, red soil

I had known the Palmist Building all of my life. Originally it was a country store run by my great uncle Sydney Duncan, my grandmother's brother. It was on my father's bread truck route, in the 1940s. When Uncle Sydney retired and gave up the store, it was rented to gypsies who read palms and told fortunes. They hand-painted the sign, a palmist sign. One day the landowner discovered the gypsies had skipped town and left the interior in shambles. He put the palmist sign in the window frame to keep the rain out. Inadvertently he stuck it in upside down, which made it more iconic for me than if it had been right side up. –William Christenberry, 2005

AARON SPANGLER

These three sculptures came into focus while I was digging a hole for my friend Bruce. We were hand-digging an addition to his underground house, which is a classic piece of hippie back-to-the-lander architecture. As people do while toiling with shovels, stories broke the surface throughout the day, many of which we've told to each other before in the course of our 25-year friendship. But this time, his narratives about the time following Vietnam, during which he moved to the woods and built his homestead, found a different hook in my imagination. I was thinking about how and why young Americans turned to the woods in search of a more meaningful, self-directed life and how that was mirrored in the movement of the early pioneers. All this is just to say that I had a plan for the piece, but it was at that moment too sensational and not yet detailed, and then I find myself digging a hole for Bruce, helping him add onto his bunker, one wheelbarrow-load after another. –Aaron Spangler, 2010

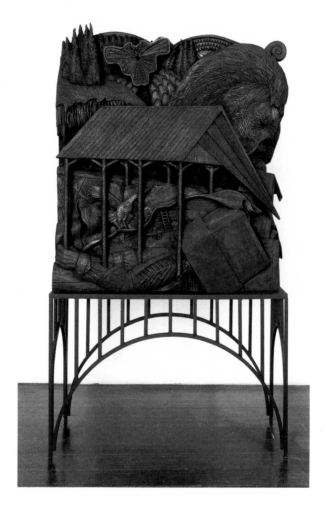

I Owe My Soul To The Company Store 2009–2010
carved and painted basswood, graphite on welded steel base

44

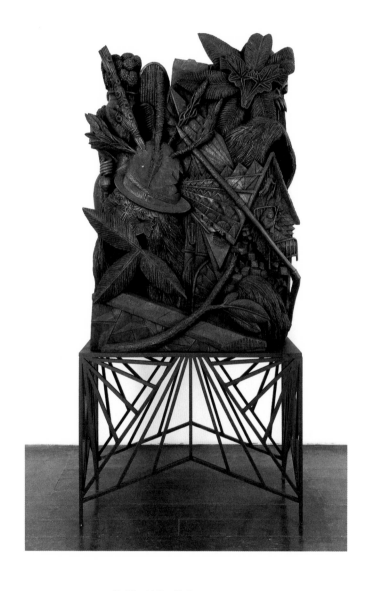

To The Valley Below 2009–2010
carved and painted basswood, graphite on welded steel base

WALKER EVANS

Want

 car

 recorder, recorder records
 letters & official entree
 consultant job classifying,
 preparing exhibition &
 analyzing with assistance
 collection intact (prints only)
 all rights retained by me
 photo supplies, films, paper, etc.
 cameras
 assistants (in Washington only)
 guarantee of one-man performance
 car
 recorder

Will give

 1 complete set prints and
 word records

—Walker Evans, handwritten note describing a Resettlement Administration job, 1935

A Miner's Home, West Virginia 1935
gelatin silver print

MATTHEW DAY JACKSON

Every cultural event that I witnessed in my younger life revolved around grunge, punk and metal.... I want to be clear, I love it all because it gave me a foundation from which to build what I am building now. I still seek louder and faster, and I am building a formal structure that is unique unto myself, in a search for being truly fluent in expressing myself. This fluency will never be achieved; I believe I will die trying. History does not live in the past. History lives in the present. I see things this way; nothing dies.
—Matthew Day Jackson, 2010

November 18, 1978 2007/2010
yarn, wood, Formica on wood

JACK PIERSON

Somebody wrote, "You can imagine him wandering Times Square looking for these letters." I just think it's funny how people really buy this notion of me wandering around Times Square in a torn overcoat picking up letters. As much as it's a notion that I would like to maintain, if I was making those word pieces out of letters that fell off signs, in four years on Times Square I would only have two letters so far.... But it's a good story as stories go. I've geared my work toward getting people to think in that way, toward having romantic allusions that they could take and run with. By present- ing certain language clues in my work, people will write the rest of the story, because there's a collective knowledge of clichés and stereotypes.... I think that a narrative can be created out of objects and images anywhere. –Jack Pierson, 1994

Beauty 1995
metal, plastic, neon tubing, wood, paint

WILLIAM EGGLESTON

I think I had often wondered what other things see—if they saw like we see. And I've tried to make a lot of different photographs as if a human did not take them. Not that a machine took them, but that maybe something took them that was not merely confined to walking on the earth. And I can't fly, but I can make experiments. —William Eggleston, 1993

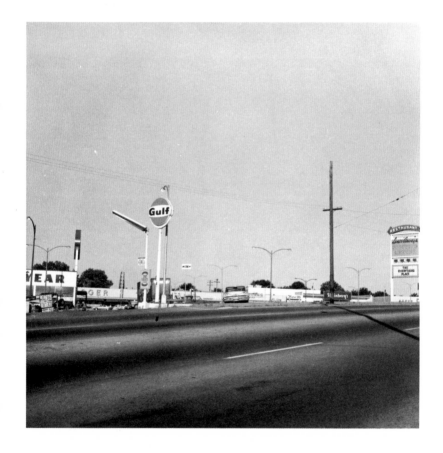

Untitled c. 1960–1965
gelatin silver print

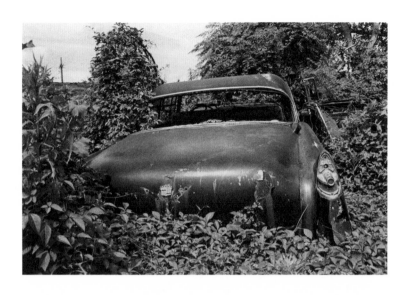

top:
Untitled (Back of Black Car in Green Vines) from the *Los Alamos Project* 1965–1974
dye transfer print

bottom:
Untitled c. 1966–1968
gelatin silver print

Untitled (Steak Billboard) Memphis, TN 1973
dye transfer print

SHANNON EBNER

I photographed the ampersand sometime around 2004. I was initially drawn to it because within its form is an infinity symbol and I was originally planning to use it as a conjoiner, a this & that article. But, as time has gone on, I have come to see the mighty ampersand within a broader context and more specifically, as a key element in my efforts to make a photographic sentence which poses the question—when is a photographic sentence a sentence to photograph—which can only be answered by trying, which in turn can only be understood through building image after image in a kind of visual ellipses, a kind of photographic &/or situation where images and objects can function as a language system.
—Shannon Ebner, 2010

Ampersand 2009
chromogenic print

The Sun as Error 2009
chromogenic print

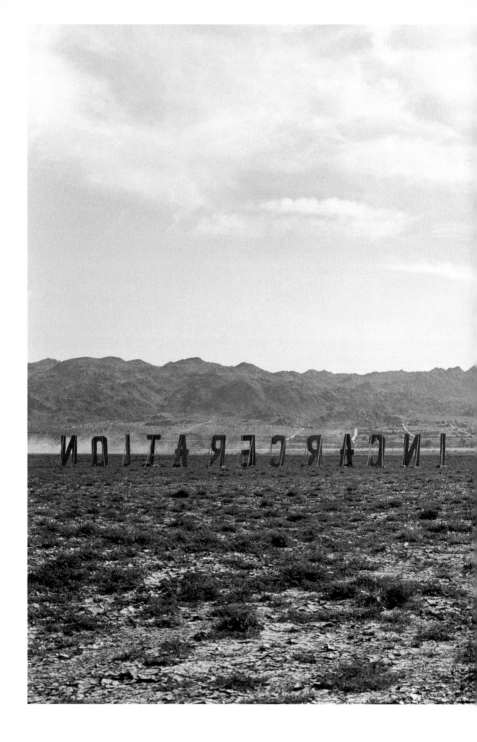

Landscape Incarceration 2003
chromogenic print

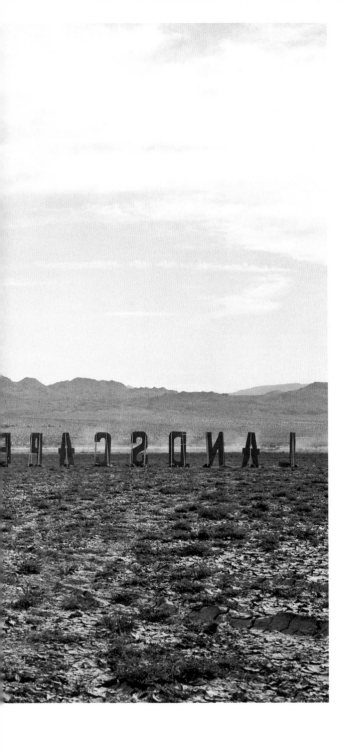

LAURA OWENS

There tends to be a sort of mundane quality to what I select—things from around the house, around the studio.... I also believe in using things that are just around—it makes sense to me. In terms of what I select from among the everyday, a lot of times there's an illusionistic quality to the objects I choose. Things that, when you pick them and maybe rearrange them, look like other things. Sometimes a collage element I hit upon can inspire the entire drawing. —Laura Owens, 2003

Untitled 2006
oil, acrylic, collage on linen

BUTT JOHNSON

Each drawing in this series features a flower from Georges Bataille's essay "The Language of Flowers," specifically those that are assigned emblematically with human emotions. Using floral motifs from multiple sources and cultures, the drawings are unified through a visual style that references the engraved line. The pastiche aspect of the work allows for each element to retain its specific vocabulary, thus suggesting that the components are interchangeable parts in the whole. –Butt Johnson, 2010

Untitled Floral Pastiche (Waterlily) 2009
ballpoint pen ink on paper

REE MORTON

Evening primrose
A ball-room beauty
Jaded, bedraggled appearance by day
Of previous dissipations
Fading flowers from last night's revelry

—Ree Morton, excerpt from the artist's notebook, 1974

Of Previous Dissipations 1974
oil on wood with Celastic

KARA WALKER

In the hundred year span between the end of the Civil War and the strengthening of the Civil Rights movement, the War never ended. The South lost the War, but unable to accept this continues to replay it. But the twenty-five or thirty years since the real end of the Civil War, which I think the Civil Rights movement brought about, has thrown Southerners into this whole other dialogue that they now have to reckon with. You know, there's the conflict between a love of the past–and of genteel whiteness as imagined to have existed in that past–and the fear of offending the sons and grand-daughters of former slaves. So the traces of the past are everywhere in the South. Polite, Southern hospitality and sweet-ness coats everything. But if you just scratch beneath the surface.... As I see it, kitsch is artworks or objects that hearken back to the days of old with sentimental excess. Items that suggest a moment or era of wholeness and innocence, like the genteel Old South where I'm supposed to breed, or the mysterious Motherland where I'm supposed to be a queen. The kitsch object breaks down all forms of transgression. –Kara Walker, 1996

Selections from *Harper's Pictorial History of the Civil War (Annotated)* 2005
offset lithographs, screenprints on paper

WILLIAM E. JONES

FSA [Farm Security Administration] director Roy Stryker routinely killed 35mm negatives by punching holes in them, thereby rendering them unusable for reproduction. Walker Evans, Theodor Jung, Carl Mydans, Marion Post Wolcott, Arthur Rothstein, Ben Shahn and John Vachon suffered the destruction of their work at his hands, but there was little they could do to prevent it.... Apart from the images themselves, the body of historical evidence relating to killed negatives is not extensive. Stryker himself gave no detailed justification for this practice. –William E. Jones, 2010

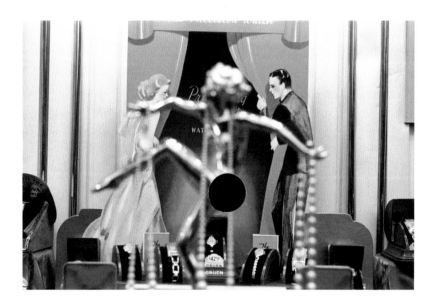

Killed 2009
Source images (1937–1939) by John Vachon from the Farm Security
Administration Collection, Library of Congress

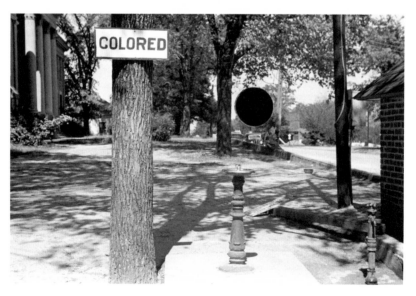

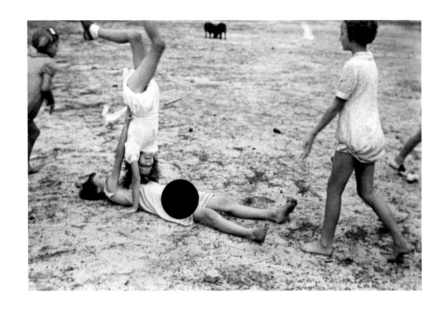

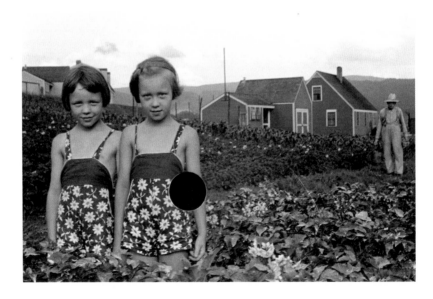

LOUISE BOURGEOIS

In the beginning tapestries were indispensable, they were actually movable walls, or partitions in the great halls of castles and manor houses, or the walls of tents. They were a flexible architecture.... I, myself, have very long associations with tapestries. As children, we used them to hide in. This is one reason I expect them to be so three-dimensional—why I feel they must be of such height and weight and size that you can wrap yourself in them.... My personal association with tapestry is for this reason, highly sculptural in terms of the three-dimensionality. —Louise Bourgeois, 1969

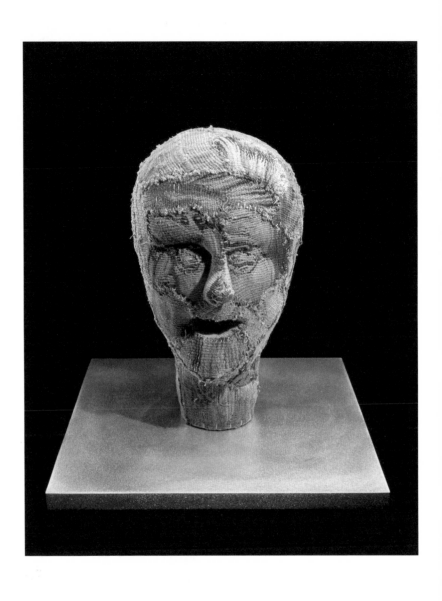

Untitled 2002
tapestry, aluminum

FAITH RINGGOLD

January 1, 1986

In this year, 1986, I will lose 128 pounds. By January 1, 1987 I will weigh 130 pounds, or I'll eat your hat. Mine I've already eaten. Faith you have been trying to lose weight since the sixties. For the last twenty, twenty-five years you've been putting yourself on diets, charting your lack of progress and gaining weight. For the next six months you'll be in California, away from every body, the perfect place to make the CHANGE.

–Faith Ringgold, excerpt from *Change 1: Weight Loss Performance Story Quilt*, 1986

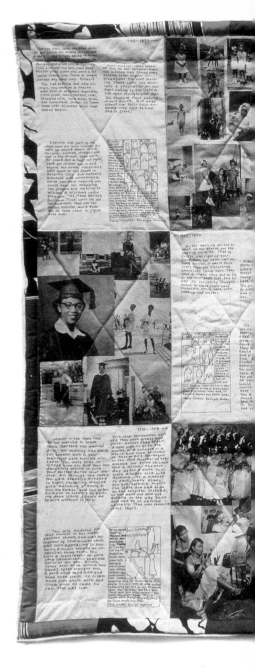

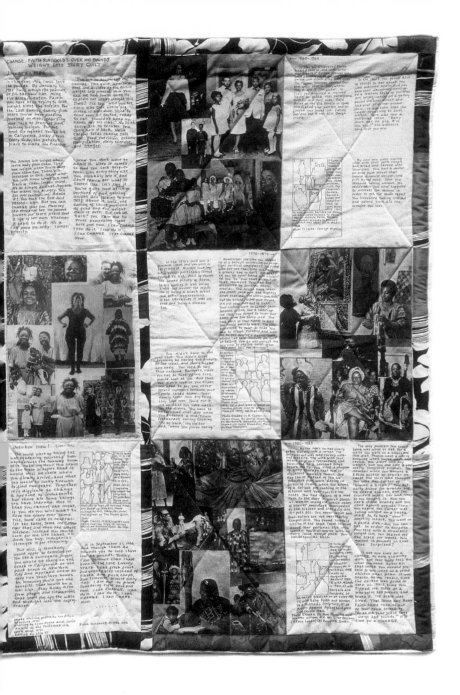

Change 1: Weight Loss Performance Story Quilt 1986
acrylic on canvas, photo lithography on silk and cotton pieced fabric

RACHEL HARRISON

I think of my work as having a simultaneous dialogue with the museum, the canons of art history, and the supermarket.
—Rachel Harrison, 2011

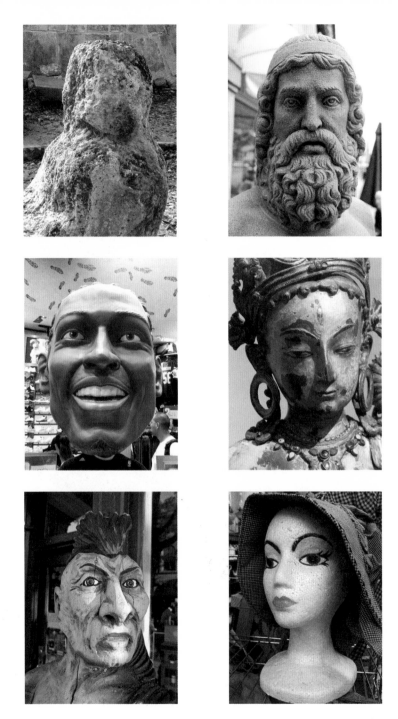

From *Voyage of the Beagle, Three* 2010
pigmented inkjet prints

75

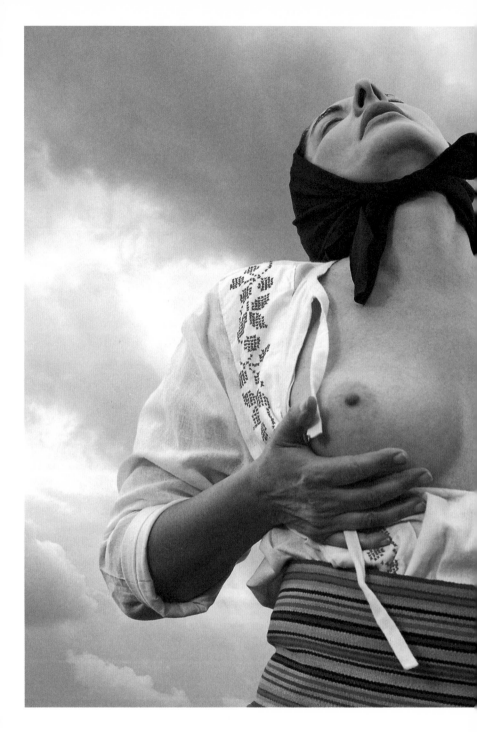

Balkan Erotic Epic: Exterior Part 1 (B) 2005
single-channel video (color, sound)
transferred to DVD

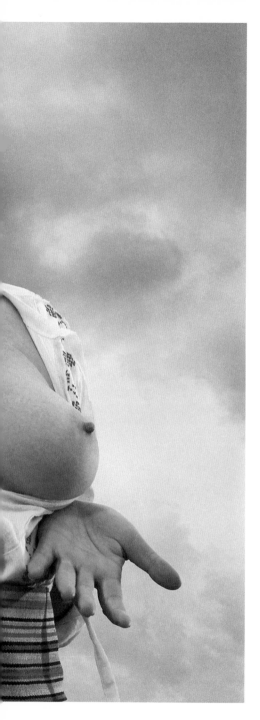

MARINA ABRAMOVIĆ

In socialist Yugoslavia everything was about sex, drinking and politics, and I wanted to explore where this came from. I did a lot of research and came across ancient pagan rituals where sexual organs are used for various purposes.... I don't think it's pornographic—anyone who sees this material bursts out laughing, but then looks at it for a long time, in silence. But at the same time there is something I can't explain: the power of our genitals, and how we can use them for healing or against the forces of nature.

—Marina Abramović, 2005

MARC SWANSON

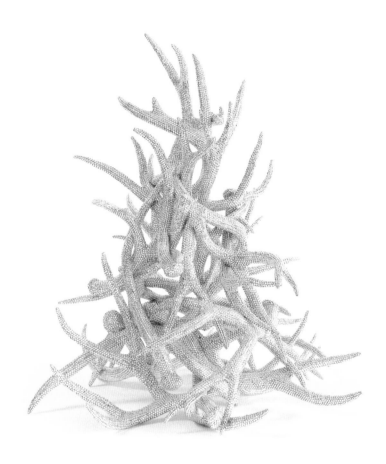

Untitled (Antler Pile) 2010
antlers, crystals, adhesive

My personal history remains a big part of my work, as does a sense of nostalgia that comes along with that. I grew up in New England, and as soon as I could, I moved to the big city. I lived in San Francisco in the early 1990s and became involved in the city's music and gay scene. I did not feel totally at home there, but I didn't feel at home as a small-town New England boy either. Some of my earliest sculptures—the crystal-covered deer heads—were a way to explore, physically and spiritually, the two very different masculine identities I was experiencing. This intersection of personal narrative and formalism is for me a kind of alchemy as well, an intimate constructivism that visually becomes an expression of all of these concerns. –Marc Swanson, 2010

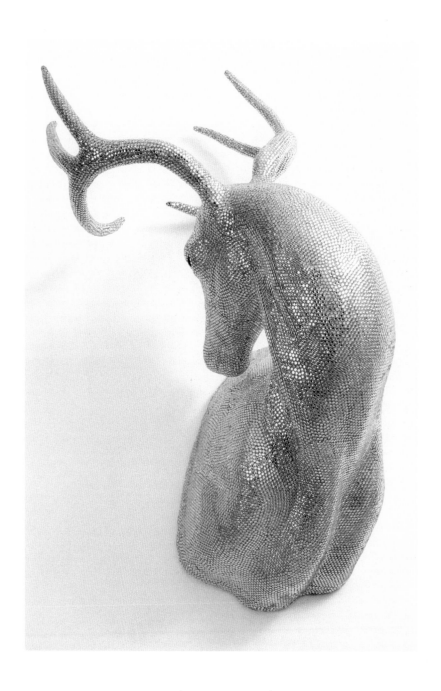

Untitled (Looking Back Buck) 2004
crystals, polyurethane foam, adhesive

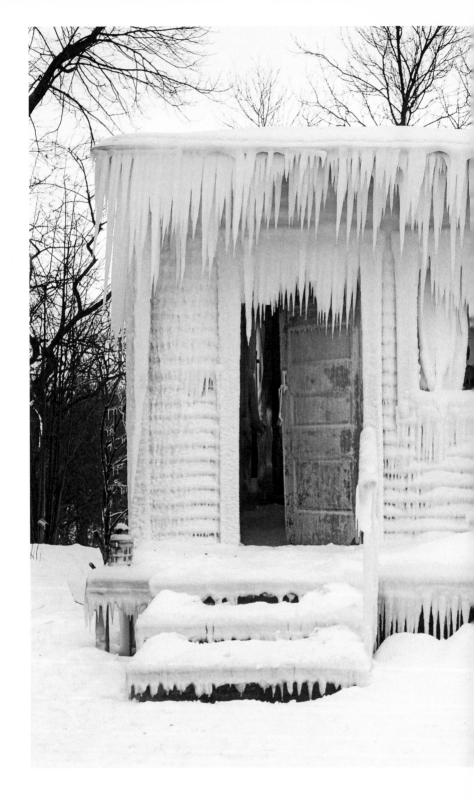

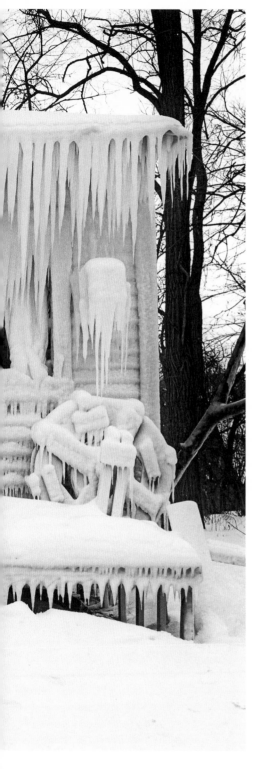

CHRIS LARSON

When I began working on the set for the ice house film, *Deep North*, I knew I wanted to build a shotgun shack; I was interested in the idea of this particular type of Southern architecture. The term "shotgun house" comes from the saying that one could fire a shotgun through the front door and have the bullet go out again through the back door. I was intrigued by the idea of a force passing in through the kitchen and out the back through the bedroom.... I also wanted to install a machine inside as though it had grown up out of the house. Ultimately, what the machine did or looked like, I did not know. —Chris Larson, 2009

Deep North 2008
chromogenic print mounted on aluminium
composite panel

JEFFREY VALLANCE

Blinky Bone 2006
mixed media

Vladimir Lenin: Relics of the USSR 2006
mixed media

Since early childhood I have been an obsessive collector, verging on neotoma (being a pack rat). I consciously started saving things in 1963, at the age of eight. I would collect objects that I thought were somehow significant, but I would also save relics from tragic-comic events and personal traumas. The first time I learned about anything akin to a relic was in 1964, when I heard that someone had obtained the bed sheets from a hotel where the Beatles had slept, then cut the cloth into pieces and offered them up for sale.

The Beatle bed sheets made an indelible mark on my brain. In 1965, my relic collection grew by leaps and bounds, until I turned my entire bedroom into a museum and regularly invited people over to see the installation of artifacts. It was not until 1971 that I started incorporating the collections into my artwork. –Jeffrey Vallance, 2008

JIM SHAW

When I am interested in something the-
matically, it tends to sit around in my head
for a long time, then eventually I'll have an
inspiration or need to act on it. As a col-
lector of thrift store paintings, I'd tried to
imagine a way of faking them, since I felt
my own hand would be too evident, and
my fantasy would have involved giving as-
signments to a class of retiree, beginner
art students. I was asked make a piece
for the Sydney Biennial [of 2002] and I
wanted to do something on the fictional
cult of Oism that was both narrative and
vague, and I had very little time, so I de-
cided to fill in some of the history, myth,
and symbolism of Oism in the form of fake
Oist thrift store paintings. I had a number
of employees who needed stuff to do that
didn't take a lot of supervision, so to keep
them busy I would suggest an image or
title, like "animals that start with the letter
O," and they would do it. I was interested
in Christian symbols like the pelican, or
the fish, whose connection to Christianity
is pretty tenuous. So I'd suggest a paint-
ing of an octopus, which starts with an
"O," like all the other animals I'd suggest,
and carries many associations within the
made-up history of Oism, some quite neg-
ative. The paintings were meant to show
various parts of Oist life—their official nail
salons, nursing homes, rituals, etc.—and
it was important that, like the first Thrift
Store series, they had a lot of different au-
thors. –Jim Shaw, 2011

Selection from *Paintings Found in Oist Thrift Store (Fantasy Oism)* 2007
acrylic on canvas board

Selections from *Paintings Found in Oist Thrift Store (Present)* 2008
acrylic on canvas board

KERRY JAMES MARSHALL

When I first started with [the black figures],
I tried to make them as flat as I possibly
could, while maintaining a sense of dimen-
sion. That was the challenge: I was trying to
see how solidly I could make those figures
resonate without putting a lot of definition
in them.... But I think I came close, even in
the flat figures, to having that blackness
breathe. To try to get that density, some-
times I painted that black five, six, seven,
eight, nine times—trying to find every com-
bination of warm and cool blackness I
could, to make them breathe more. From
the start, that was my objective: to be re-
ductive and not reductive at the same time.
—Kerry James Marshall, 1999

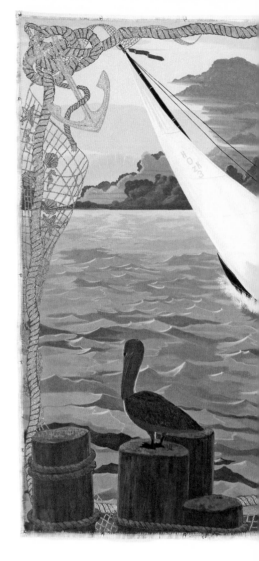

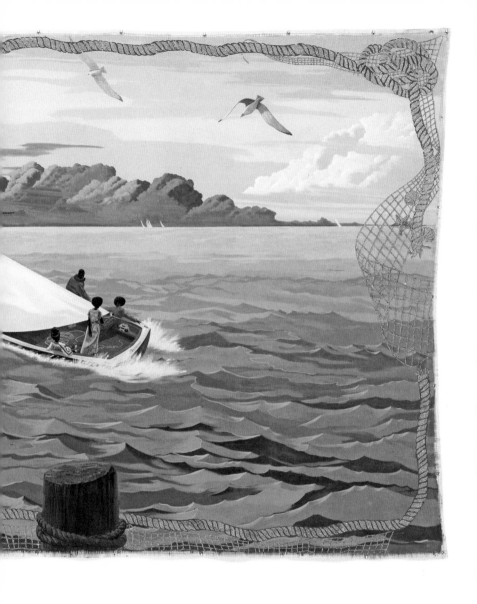

Gulf Stream 2003
acrylic, glitter on canvas

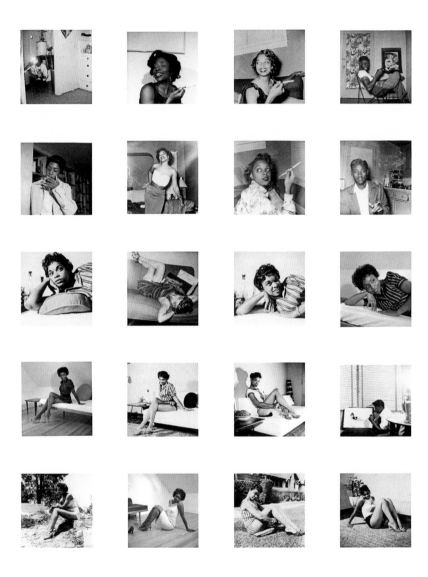

[This series] started with a photograph, which I found on eBay. After I received it, the seller contacted me and said, "Oh, I have about 250 photographs of this person. Are you interested in purchasing them?" I agreed and received these amazing albums made by an anonymous woman in Los Angeles who photographed herself in these Hollywood quasi-actress poses. The album did not contain family photographs or trips or day-to-day life. I got the idea to insert myself into her scene, into her three-month project. It was painful to try to mimic her physically—it felt like yoga positions. In doing so, I wanted to insert myself invisibly. −Lorna Simpson, 2010

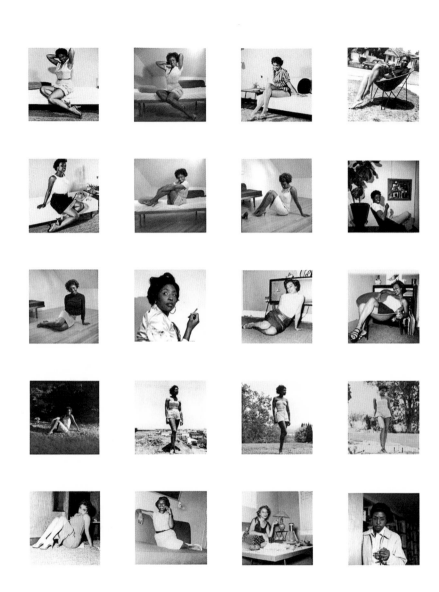

1957–2009 Interior #1 and *LA '57–NY '09* 2009
gelatin silver prints

MIKE KELLEY

Crafts are the literal embodiment of the Puritan work ethic. They seem to announce that work is its own reward. This is spoken through the long, labor-intensive hours it takes to construct them by hand (and in that they perhaps harken back nostalgically to a pre-industrial economy). They also speak in the language of the wage-earner where there is a direct one-to-one relationship between time spent and worth. The equation is not between time and money, it is a more obscure relationship drawn between time and commitment, one that results in a kind of emotional usury. The gift operates within an economy of guilt, an endless feeling of still-owing attends it because of its mysterious worth. And the incredibly loaded nature of these objects is intensified by their material nature, by the seeming contradiction that their emotional weight far exceeds the worth of the cheap and lowly materials from which they are constructed. –Mike Kelley, 1991

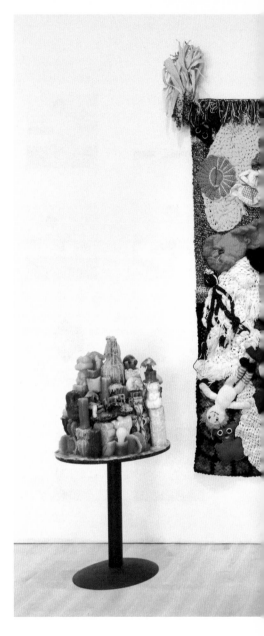

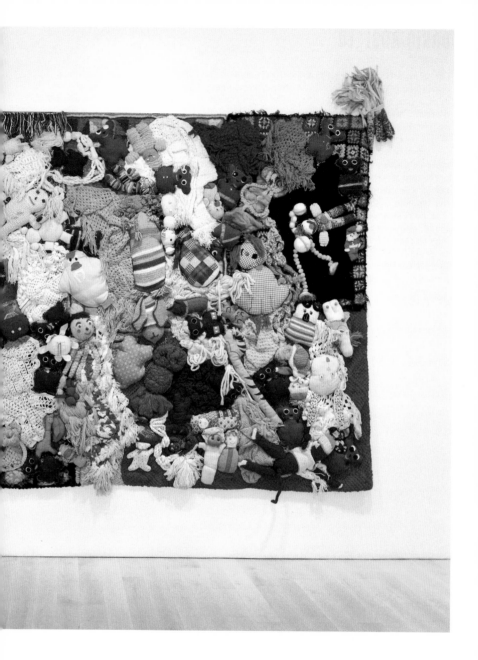

center:
More Love Hours Than Can Ever Be Repaid 1987
stuffed fabric toys and afghans on canvas with dried corn

left:
The Wages of Sin 1987
wax candles on wood and metal

DARIO ROBLETO

I base my artwork on original source material, including letters, diaries, and mementos connected to nineteenth-century histories of mourning. This is, in effect, a history of creative response to loss. What happens to your brain when you are under tremendous duress? There is a wonderful rich history of unexpected leaps in aesthetics by everyday people when they are forced to address everyday problems as well as the catastrophes of life. There is a "logic of loss," in a sense.

History is full of such strange moments and gestures: the women stationed at makeshift hospitals during the Civil War who would write letters for amputee soldiers, or the rare female lighthouse keepers who often gave up a normal life to dedicate themselves to keeping those lights on for the safe return of sailors and soldiers. And there is the tradition of the Sailor's Valentine itself, of sailors trying to find a creative outlet for their homesickness on the endless hours at sea. Although my work often draws on outdated forms of craft and ways of thinking, it is always an engagement with the here and now and the delicate ties that bind today to the past. This is a part of a body of work that originated after September 11 and was meant to reconnect viewers to past traditions that are overflowing with others' examples of how to produce a creative response in the face of such unexplainable loss. −Dario Robleto, 2010

Demonstrations of Sailor's Valentines 2009
cut paper, various seashells, colored wax, *cartes-de-visite*, silk, ribbon,
foam core, glue

LARI PITTMAN

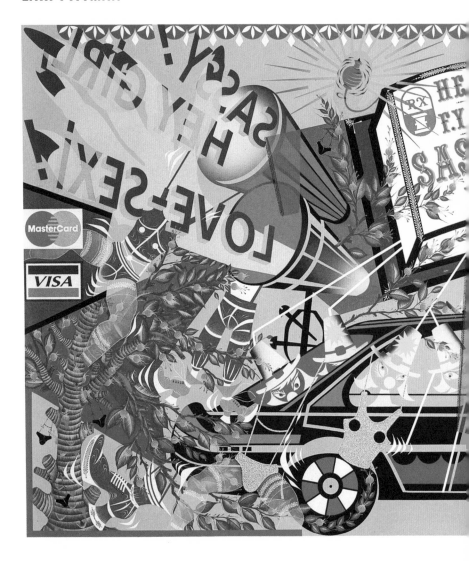

I am interested in the idea of simultaneity–the issue of time. Growing up I could see the difference between my father's Protestantism and my mother's South American Catholicism, which was fueled by emotions. Generally Latino culture entertains the simultaneity of time, whereas capitalism and Protestantism reinforce sequential, Calvinist time. The paintings are noisy, filled to capacity. They propose an exuberance and an ornamentalization. Yet insofar as they function this way, they may also be about the opposite experience, one of existentialism or nihilism. –Lari Pittman, 2010

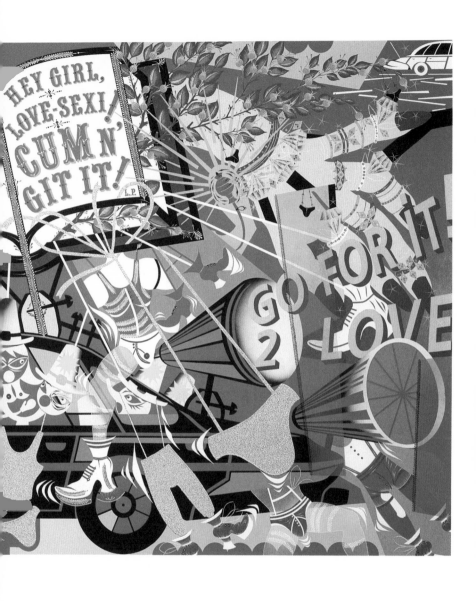

A Decorated Chronology of Insistence and Resignation #30 1994
acrylic, enamel, glitter on wood panels

VERNACULAR

FROM
DISCOVERING
ᵀʜₑ VERNACULAR
LANDSCAPE

JOHN BRINCKERHOFF JACKSON

VERNACULAR

The increasing interest among architects in what we call vernacular architecture and the growing public awareness of a rich vernacular heritage suggest that it is time we examine the nature of the vernacular and its historical development.

As generally used, the word suggests something countrified, homemade, traditional. As used in connection with architecture, it indicates the traditional rural or small-town dwelling, the dwelling of the farmer or craftsman or wage earner. Current definitions of the word usually suggest that the vernacular dwelling is designed by a craftsman, not an architect, that it is built with local techniques, local materials, and with the local environment in mind: its climate, its traditions, its economy—predominantly agricultural. Such a dwelling does not pretend to stylistic sophistication. It is loyal to local forms and rarely accepts innovations from outside the region. It is not subject to fashion and is little influenced by history in its wider sense. That is why the word *timeless* is much used in descriptions of vernacular building.

This definition is largely the product of architects and architectural historians, hence the emphasis on form and building techniques and the relative neglect of function or of the relationship to work and community. In fact architectural scholars may be said to have discovered the vernacular and to have done much of the early research into its characteristics. The current definition has been very serviceable. Nevertheless it should be noted that it derives for the most part from the mid-nineteenth-century exploration of rural life by antiquarians and those dissatisfied with urban, industrialized life. Of late years the study of vernacular building has been greatly influenced by speculations on the psychology and mythology of traditional man-made spaces. It owes much to the interpretations of Jung and Eliade and Bachelard and even Heidegger, none of whom was much concerned with the economic or political aspects of the dwelling.

But other disciplines also have been involved in studying the vernacular. Much work has been done by geographers, social historians, and archaeologists, and they have contributed to a broader, more prosaic definition of vernacular architecture that we cannot afford to ignore. To put it briefly, what they have done is to reveal that vernacular building, especially in Europe, has had a history of its own, distinct from that of formal architecture, and that far from being "timeless" and determined by ancient archetypes, it has undergone a long and complicated evolution.

What chiefly concerns us as Americans are the more recent chapters in that European chronicle of vernacular buildings—roughly from the sixteenth century onward. (The usual cutoff date is the mid-nineteenth century.) A period once thought of as the heyday of the so-called timeless forms of vernacular architecture—the sixteenth and seventeenth and early eighteenth centuries—has now been revealed as a period of far-reaching changes, not only in the design and construction of the dwelling, but in its economic and social functions and even in its legal

definition. This fateful period corresponds of course to the period when the first colonists from Atlantic Europe arrived in North America. They brought with them, in other words, a revolution in vernacular architecture, and it was here in the New World that that revolution has been carried through to the present.

This is not the place to discuss the origins of that revolution. We need only recall the Enclosure Movement in England, the growing scarcity of wood, the development of planned communities throughout Europe, the coming of manufacturing, and above all what Philippe Ariès calls "the discovery of the child," to realize that a new type of dwelling with new uses *had* to evolve. It was, even in Europe, a type which did not conform to that popular academic definition which we still use. It was not simply rural and agricultural, it was identified with mining and shipping communities, with cities and the architect- or engineer-planned villages having a military or political function. Finally it used materials and techniques imported from elsewhere. And yet because it was an architecture meant for farmers or craftsmen or wage earners it still qualified—and is still thought of—as vernacular.

Many of these novelties were brought to America by the settlers and the colonial authorities. What gave this imported vernacular its uniquely American quality was the abundance of wood for construction, the abundance of land, the rapid increase in the young population, and the scarcity of skilled labor. Out of this combination of Old World and New World factors came a vernacular style characterized by short-lived or temporary dwellings focused on the family and distinct from the place of work, dwellings largely independent of the traditional community constraints and institutions, dwellings using new construction techniques, and with a new relationship to the environment.

Can we write a history of the American vernacular dwelling in terms of these and similar traits? I think we can. The temporary or movable dwelling has been a feature of the American landscape ever since colonial times. The dwelling as an environment for the child-centered family, urban as well as rural, has inspired the replanning of the dwelling, the increase in the number of rooms, and the introduction of utilities and conveniences long before they were introduced in Europe. The American vernacular home, designed as a microenvironment, is dependent on the community not as a political entity but as a source of services, and we have accordingly developed settlement forms of a nonpolitical sort: the suburb, the company town, the trailer court, the resort area, and the condominium.

The structural innovations which our vernacular architecture has introduced are well covered in every architectural history: the log cabin, the balloon frame, the box house, the ready-cut, or prefabricated, house, and the mobile home. But a chapter yet to be written by historians would deal with the vast amount of modification and improvement, interior as well as exterior, that almost every American householder undertakes.

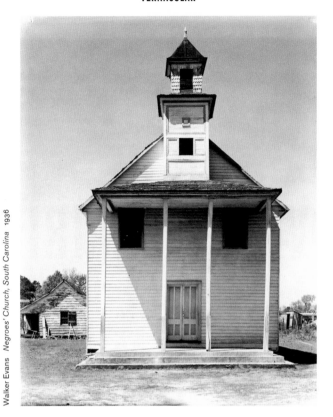

Walker Evans *Negroes' Church, South Carolina* 1936

Thanks to our tradition of building with wood, and thanks also to the recent introduction of power tools, we are becoming a nation of amateur carpenters and electricians, not always knowing when to leave well enough alone.

I hope I am aware of some of the shortcomings of contemporary American vernacular architecture. Compared to traditional, pretechnological dwellings ours are spiritually and culturally impoverished. Our almost uncontrollable love of making "environments"—never stronger than now—compels us to create in our houses as well as in our cities environments that are good for nothing but health and recreation, environments almost entirely without content. And I know how fatally easy it is for us to produce short-lived communities composed of flimsy and undistinguished architecture. It is certainly part of any study of American vernacular to point out these and other mistakes and to remind us how they were avoided in the past. At the same time we would do well, at least in the beginning, to avoid passing easy, subjective judgments. A prosaic, conscientious, and reasonably sympathetic study of our wonderful profusion of vernacular architecture—a profusion that shows no signs of abating—would lead to a better understanding of many aspects of everyday America and how they came into being.

AT
NIGHT
OVER THE PRAIRIE
WE SEE A
SPLENDID MIRAGE,
A VAST
TERRITORY
ARISING AMONG
US,

A VILLAGE IN THE AIR, WITH HAY-COCKS LIKE CASTLES, MIRRORED IN THE SKY WITH NO DIVISION BETWEEN REAL AND UNREAL.

– A NINETEENTH-CENTURY MIDWESTERN SETTLER [01]

Hello from AUSTIN, MINN.

Traveling Minnesota's Highways

YOU'RE NOT NOWHERE!

VISUALIZING THE HEARTLAND VERNACULAR

ANDY STURDEVANT

What do you know about this mythical, so-called heartland, wellspring of America's strength, ingenuity, and goodness? If you know one thing about it for sure, you know this: it is flat.

These are the lines you generally hear: "It's really flat. You can see for miles. The landscape goes on forever." (One also hears, "It's empty," which is a no less important and very closely related point.) The flatness is what people refer to about the Midwest when they drive through from the east, or the south, or the west—from the mountain ranges, or the towering, ancient forests, or the canyons or the cliffs or the rolling bluegrass hills. Nearly everywhere else in America, the landscape is defined in terms of its verticality. *Purple mountain majesties, above the fruited plain.* See, the fruited plains are defined in their relation to the purple mountains' majesty. There's an x-axis (plains), and a y-axis (mountain majesties). Not so in the Midwest, goes the story: it's all x-axis.

Well, that's not entirely true. When the Wisconsin Glacial Episode ended 10,000 years ago, it did leave wide swaths of pancake-flat prairie from the Dakotas all the way to northern Ohio. However, it also carved out the cliffs along the Upper Mississippi, the Badlands of South Dakota, and the Great Lakes themselves. I mentioned this notion of the Midwest's utter flatness to an artist I know who grew up in Winona, a city that rests in the scenic bluff country running through the southeastern part of Minnesota, known for limestone peaks and the massive rock formation called Sugar Loaf. My friend scoffed and waved his hand. "Winona," he said with great disdain, "is not flat."

Of course it's not, no more than it's empty. But it's the flatness that most people experience, and then tell you about when you meet them and mention you're from one of those mysterious, blocky states between the Great Lakes and the Rockies. This flatness is easily conflated with emptiness. Perhaps this is merely a result of the way the interstates are laid out; as writer Michael Martone has noted, they "skim along a grade of least resistance," bypassing any elevation or charm for grim, straightforward, mid-century efficiency. [2] A trip through the region on the interstate gives the impression of a headlong automotive sprint through a vast, empty space, barely populated except for billboards, grain silos, and garish come-ons for gas, food, or shelter. Or perhaps it's the way the region appears from an airplane, all tidy blocks of land, parceled out endlessly in squares, interrupted only very occasionally by a river or highway. Basically, any way you travel through, over, or past it, the further west you move, the more you have the impression of a vacuum all around you.

Again, my friend from Winona or anyone else who lives and works here would scoff and wave their hands at that idea as well. Certainly it's not empty. *We* live here, after all. And we'd be right, of course. On the other hand, it's hard to dismiss this interpretation outright. Over the course of the past few hundred years, the land *has* been thought of as

BM. 19—Paul Bunyan and Babe, his Blue Ox
Bemidji, Minn.

empty by almost everyone who passed through it. A space, waiting to be filled.

And what is this empty space filled with? What do you envision? A short list: roadside attractions, summer resorts, rock gardens, Native American burial grounds, caves, mom-and-pop diners. Barns with tobacco advertisements painted on the side, motor lodges proclaiming air conditioners and color television, historic battlegrounds with solemn, bas-relief markers. An oddball amalgamation of timber, faux-leather buckskin, stones, garish paint, fiberglass, vinyl, varnish, concrete, neon lights, and ambiguously ethnic decorative patterns coexisting in a kaleidoscopic crush of color, texture, and origin that seems a little bit familiar to anyone and a little bit otherworldly to everyone. It seems alternately disposable, modern, seedy, wholesome, and improvised, a strong, overstated reaction to the flatness and barrenness surrounding it. This is the visual language of the American vernacular, the hybrid style that filled the vacuum in the middle of the continent and eventually became shorthand for the whole place. "Americana," right?

Empty is how the people who made the decision to come live here thought of the place. That mythical idea of the West, where you begin again from scratch, where you build a house, a farm, a town, or a region using only the best elements of what you know from back home, while jettisoning the parts you don't like—the repression, the poverty, the crowds. You build a new life wherever you've ended up. There's this insistent idea, too, that any attendant culture could be started again as well. There's no tradition, no heritage—at least, not in the same way a European would recognize those concepts or, actually, even in the way a Southerner or New Englander would recognize them. Those parts of America are filled with reminders of events long since past, solemnly preserved and constantly paid lip service to.

It's not hard to imagine that this is why people came to the empty and flat expanses of the middle of the continent in the first place, especially from the East—to get away from all of that goddamned history. For example, plug the phrase "old, Boston MA" into Google Maps. An outbreak of little red dots marks the various "old" points of interest on the map: the Old North Church, Old South Church, Old South Meeting House, Old State House, Old Saint Stephen's Church, Old Harbor, Old Colony Avenue, old building this, old road that. Walking around in a colonial city such as Boston or Philadelphia or Charleston, the weight of history is constantly crushing down upon you.

Not so in the Midwest. Whatever "heritage" there may be is handmade from the ground up. It's heritage based not upon longevity and lineage but on sheer force of will: again, disposable, modern, seedy, wholesome, and improvised. These parts were assembled by a heterogeneous cast of characters from all over, with wildly different ideas and intentions. This particular strain of Americana is utterly democratic, taking visual cues from anywhere, paying homage to any idea that may

seem important at any given moment. A friend recently found himself in a small crossroads village in the Dakotas. Near his motel, he found a town square-cum-municipal park decorated with a painted World War II tank, some dinosaur bones, and a statue of an Indian with a dog. The utter sincerity and utterly unselfconscious strangeness of this arrangement speaks more honestly about the lives, values, and aspirations of the local population than a cluster of neoclassical marble columns would.

With several critical exceptions, no one has been in the Midwest for all that long. Certainly not in the geologic or historical senses, and not even in terms of the four-hundred-some-year lifespan of what we know as North America. You meet very few people here who can claim a lineage in this area stretching back past their great-grandparents. Most people, when asked, will give you a variation on the narrative that has defined the region in the popular imagination for several generations—"My parents came here from New York," they'll say. Or "My grandparents came up from Illinois, where their parents had settled after leaving Ohio." Always in prepositional phrases—*up* from Tennessee, *across* from Pennsylvania, *over* from New England. Or even further out. "My great-grandfather was from Finland and came here for a mining job on the Iron Range." "*Babcia* came from Poland." "My *dědeček* came from Bohemia." Even the old money, the families whose names one finds attached to homegrown multinational corporations and arterial city streets, were opportunistic Easterners arriving only a few generations ago. I, like many of my peers, personally have no ancient claim on my adopted hometown, Minneapolis. No claim, that is, other than the fact that I've lived here just long enough to gesture to certain sites from bus windows and be able to say, "That's the gallery where I met my friend Geoff a few winters ago." Looking at my own family's trajectory, most of the arrows one might draw on a map to mark progression would go left-to-right, from here back to Kentucky, then Ohio, then up into Pennsylvania and New York state and then at some point back across the ocean to provincial towns in England and Scotland and Holland, and back into that misty, unknowable era of buckled Pilgrim shoes.

As Jonathan Raban suggests in *Bad Land: An American Romance* (1997), his account of driving through the Dakotas and Montana, traveling east in America is traveling backward through time. The forward momentum is always westward. One even sees a variation of this idea of time and distance on a micro level, in the urban centers of the Midwest. You start by the lake or the river on which the city was founded, near the oldest buildings—the warehouses and churches and mills. You then travel through time outward, until you splat against the modernist blandishments of the first-ring suburbs or the 1960s, whichever comes first. I am certain one could break this down into a driving game with a measurement-based mathematic formula of some kind—once you've

"Sugar Loaf", near Winona, Minnesota. Photographed about 1898.
Collected by John Runk, photographer, Stillwater, Minnesota U.S.A.
Historical Collection No. 275

passed the Alleghenies or Cumberland Gap, you add, say, five years for every mile westward you go starting at 1800, accelerating until you've hit the Continental Divide or mid-century. Whichever comes first.

The only people who can claim any long-term relationship to this land are Natives—the Dakota, the Ojibwe, and a hundred others, who set up hunting and settlement cycles sometime in the fifteenth century and thrived until they were pushed out and eliminated by a succession of white Manifest Destiny–crazed colonists and invaders. Before the conquest was even complete, they were blithely absorbed into the popular imagination, "a proud yet primitive people finally giving way to a more accomplished society foredestined to supplant them," as cultural historian Michael Kammen explains it. [3] Henry Wadsworth Longfellow's massively popular 1855 poem "Song of Hiawatha," set in this mythical Midwestern neverland, had already consigned the Plains Indian to dreamy historical myth, decades even before Little Big Horn and Wounded Knee. As the *New York Times* wrote of the poem at the time, it embalmed "the monstrous traditions of an uninteresting, and, one may almost say, a justly exterminated race." [4] The Midwest was empty, perhaps, because it was consciously emptied.

The names given to these spaces mirror the confused, improvisatory jumble of the man-made landscape. They're cribbed from everywhere—French mispronunciations of Indian words, legitimizing Latinate and Greek fragments mashed together, and references to religion, the landscape, history, or to other cities entirely. Chicago, Minneapolis, Milwaukee: Wild Onion, City of Water, Good/Pleasant/Beautiful Land. St. Louis, St. Paul, St. Charles, St. Cloud. Omaha, Peoria, Waukegan, Fargo. Madison, Lincoln, Jefferson City. Des Moines, Detroit, Champaign, Fond du Lac. Green Bay, Grand Rapids, Grand Forks, Little Falls, Garden City, Platte City. Some grow up overnight, some flourish, some dry up and disappear. Some die choking, undignified deaths. Millions and millions of people spread across thousands of miles of open space, and few of them there for significantly longer than any other.

That's why I've always found the idea of "the heartland" as a metaphorical flourish so odd and inappropriate for the Midwest. The heart is the center of the body physically, just as the Great Plains are the geographic center of the country. But think of driving through the exurban interstate corridors in the region's right-wing strongholds and coming across those anti-abortion billboards that picture a gurgling baby proclaiming, "My heart was beating at 3 weeks!" The "heart" metaphor in "heartland" is getting mixed here, since the heart is also among the earliest organs to develop. The rest of the body grows out from the heart. How could someplace as recently populated and as hastily improvised as the Midwest be the heart of a country settled at least a century or two earlier than it is? If the Midwest is the heart of this land, it's an artificial heart, one that's cobbled together from the parts that were lying around.

That very self-conscious, deliberate manufacturing of heritage creates a certain compression of nostalgia. Oftentimes, especially here in the urban parts of Minnesota, you'll hear people talk about the "old Minneapolis" or the "old St. Paul"; they're talking about things that aren't more than forty years old, which almost anywhere east of here is a millisecond, the snap of a finger. They're not delusional. The Minneapolis or St. Paul they knew *is* in fact gone, paved over or demolished to make way for something else. The next time you're on a Minneapolis junket, find an old artist and ask him or her about, say, Rifle Sport Gallery or the New French Cafe. The painful story you'll hear subsequently happened just twenty short years ago, but it will be told in such a way that it sounds like it might have happened in a Jacques-Louis David painting. It's not just Minneapolis, of course. Go to Fargo and ask someone about Ralph's Corner Bar, or Madison and ask about Manchester's, or Milwaukee and ask about the Schlitz Brewery. Or …

Maybe, come to think of it, the heart isn't a bad metaphor for this place after all. The heart pumps away, billions of times in a lifetime, and new blood rushes through it, replenishing itself every few minutes. So it is here: an endless, reflexive cycle of renewal, the substantive oxygen-carrying matter replenishing itself every few decades. One has to grab whatever might seem like *heritage* and hold onto it so that it's not carried away in the next cycle. Driving through the still-empty expanses of the heartland and coming across the remains of lakeside resorts, railroad towns, motor lodges, and farming homesteads, only a generation or two removed from use, one realizes how swift and merciless this process can be.

One does not associate the Midwest with acts of spontaneous creation in the twenty-first century. It is a closed frontier, a punch line about the cultural wasteland that ambitious college graduates flee for the excitement and opportunity of the coasts. It is a region that, depending to whom you speak, has permanently plateaued or is now actively in bad decline. A laundry list of Midwestern dysfunction and decay would include the broken, internally crumbling cities of the Rust Belt, the desiccated and foreclosed farmsteads of the Plains states, or the sprawling exurbs and interstate off-ramps filled with interchangeable fast food restaurants and big box stores that have killed off the fabled main streets.

That said, I sense I am slipping here into idealization, just the sort that I suspect people came to the Midwest to escape. The prairie is not a sentimental place. There is certainly room for regret—and one cannot travel through these cities or farmsteads without feeling it—but largely, the vernacular landscape is a testament to constant improvisation and a compulsive need to renew and reinvent. The past is not necessarily something to preserve wholesale, but something to strip down for parts. The inherent problem with such an improvisatory landscape is that once you begin anew, it's hard to not keep beginning anew over

BR. 22—Paul Bunyan Playground, Brainerd, Minn.

and over, until you've done it so many times you've lost sight of the things that might give that landscape meaning.

The last time I was in Fargo, it happened to be the fifth anniversary of the demolition of the aforementioned Ralph's Corner Bar. Ralph's and its green-and-red buzzing neon "OFF/ON" sign was an old-man 1940s dive bar across the river in Moorhead, Minnesota. It boasted, apparently, the finest jukebox between Seattle and Minneapolis, and was the only real stop for any touring band traveling along that old Empire Builder route between the west and east. The weekend I was in town, it just so happened that there was a two-night concert memorializing the bar's demise, held at a venue just a mile or so from the old site. Most of the attendees were roughly my age, but it sounded like they were talking about events that had transpired back in the territorial days. Perhaps this is simply hipster nostalgia, but I think it's something more complex.

For example, some kid hanging around the bar had on one of those ubiquitous CBGB T-shirts, and I was struck by how strangely timeless that equally defunct punk-rock venue seems, particularly when compared to Ralph's. CBGB was shuttered around the same time, but it also seems less absent, more of an eerie, malingering presence. It only feigns death, living on through merchandise and branding. Ralph's doesn't impart that sense—Ralph's isn't coming back, in any form. It's a memory, treasured by a few thousand North Dakotans and Minnesotans. Ralph's and its sputtering neon sign—the kind one could easily imagine appearing in any number of dry-transfer color photographs of similar bar marquees at any point in the past seventy-five years—never fell into decay, because it was not allowed to decay. Instead, it vanished almost overnight, leaving only a vague sense of collective guilt at the cruelty and violence of these endless cycles. The Carnegie libraries of the Midwest—those still standing—are full of picture books teeming with grainy, black-and-white photographs of whole city blocks that were built, lived in, used up, and then taken down again, all generations before you were born.

There is a kind of anti-preservation at work in the visual elements that are left behind: the decaying bar signs, tourist camps, timber lodges, no-tell motels, barn sides, fiberglass teepees, and hand-painted billboards that dot the rural and urban Midwestern landscape. There is a kind of dignity in the fact that they were permitted to remain at all, that they weren't flattened as soon as they outlived whatever usefulness they might have been assigned at the time of their creation by the people who envisioned them. Writer and photographer Brad Zellar notes, "What these things usually say to me are 'This is who we are!' Or 'This is who we were!' Or 'This is who we'd very much like to be!' " [5] The fluidity between those categories is significant; in fact, to this list I might even add a poignant, "This is who we would like to have been!" So much of this past, as close to the surface as it is, is both genu-

inely celebrated and willfully obscured to the point where one begins to forget what is worth preserving and what is disposable. It keeps changing. The landscape is filled and emptied and filled again, over and over and over.

Zellar continues: "Their other primary function, it always occurs to me, is that they are proclamations to the effect of 'Believe it or not, you're not Nowhere!'" [6] Indeed you are not, because this heartland and the scatterings of people strewn across its flat and endless expanses have been actively, painstakingly creating a Somewhere as long as they have been here. They keep creating and re-creating Somewhere, too. If we are lucky, we can catch glimpses of the raucous, ramshackle, and glorious-in-spite-of-itself artifacts they leave behind, before it is all torn down and made into a distantly familiar but still-new Somewhere once again.

NOTES

[1]
A nineteenth-century Midwestern settler
quoted in Meridel Le Sueur, *North Star
Country* (New York: Book Find Club,
1945), 9.

[2]
Michael Martone, *The Flatness and Other
Landscapes* (Athens, GA: University of
Georgia Press, 2003), 1.

[3]
Michael Kammen, *Mystic Chords of
Memory: The Transformation of Tradition
in American Culture* (New York: Alfred A.
Knopf, 1991), 58.

[4]
"Longfellow's Poem," *New York Times*,
December 28, 1855, http://query.nytimes.
com/mem/archive-free/pdf?res=F3081EF
B3B59157493CAAB1789D95F418584F9.

[5]
Brad Zellar, e-mail message to author,
August 13, 2010.

[6]
Ibid.

ANNOTATED READING LIST

From casseroles and denim to high versus low and academic inquiry into colloquial life, the vernacular has been scrutinized and celebrated in an array of texts and publications. This compilation of writings by scholars, historians, curators, and aficionados offers insights into some of the ideas that inform the exhibition.

UNDERSTANDING VERNACULAR

Conwill, Kinshasha Holman. "Feeling at Home with the Vernacular of African-American Art." In *Testimony: Vernacular Art of the African-American South*, 54–63. New York: Abrams, 2001.

On the occasion of the exhibition *Testimony: Vernacular Art of the African-American South–the Ronald and June Shelp Collection*, lauded writer and curator Conwill discusses the complicated position of vernacular art within the larger canon of African American art. She notes that the complex systems that monitor and ascribe authenticity within the history of African American culture have a very particular relationship with the representational hierarchies that affect the construction of identity.

Heath, Kingston William. "Assessing Regional Identity Amidst Change: The Role of Vernacular Studies." *Perspectives in Vernacular Architecture* 13, no. 2 (2006/2007): 76–94.

Rather than take the position that vernacular must be *prescribed* to settings, buildings, and time periods, this article explores the subject from a more dynamic, accommodating position. Heath contends that architecture, like other aspects of the local and the regional, is shifting over time alongside the various identities it houses.

Jackson, John Brinckerhoff. *Discovering the Vernacular Landscape*. New Haven, CT: Yale University Press, 1984.

Compiled from a series of lectures by the influential American vernacular historian and theorist, this anthology is a cornerstone publication about architectural landscapes of the United States. Jackson addresses ways that space, place, and architectural structures of urban, suburban, and rural America affect the understanding of everyday life therein.

Marling, Karal Ann. *The Colossus of Roads: Myth and Symbol along the American Highway*. Minneapolis, MN: University of Minnesota Press, 1984. Reprint, 2000.

Taking the position that roadside monuments are an extension of the grand tradition of American storytelling and a collective impulse to both roam and be noticed, art historian Marling investigates the origins and influences of such curiosities as the World's Largest Ball of Twine, Salem Sue, and the Jolly Green Giant, which flank roadways across Minnesota and the greater United States. From fantasy and legend to civic pride and tourist destinations, the book details the enduring popularity of these attractions, signaling their larger importance in the collective imagination.

Upton, Dell, and John Michael Vlach, eds. *Common Places: Readings in Vernacular Architecture*. Athens, GA: University of Georgia Press, 1986.

An assemblage of twenty-three essays pertains to what the editors describe as "the structures of ordinary people of 'common places'" with a focus on American vernacular architecture. Perspectives range from historical and sociological to geographical and architectural, providing a breadth of detail about the buildings that pepper the topography of the United States and shedding light on the people who have inhabited them.

Venturi, Robert, Denise Scott Brown, and Steven Izenour. *Learning from Vegas: The Forgotten Symbolism of Architectural Form*, rev. ed. Cambridge, MA: MIT Press, 1977.

An important study advocating for the consideration of the role roadside signage, commercial developments, and urban sprawl play in giving meaning to various landscapes, this book focuses on the Las Vegas strip as an example of ways that these often castoff architectural ele-

ments can be connected to, and enriched by, symbolism. This notion was in direct opposition to the predominance of cold and industrial modernist design at the time. Through a series of texts and illustrations, the authors propose that Las Vegas provided a template for the incorporation of high and low culture in postmodern architecture, making it much more persuasive than its stylistic predecessors.

Vellinga, Marcel. "The Inventiveness of Tradition: Vernacular Architecture and the Future." *Perspectives in Vernacular Architecture* 13, no. 2 (2006/2007): 115–128.

From a perspective outside of the traditional scope of vernacular architecture, this article emphasizes the stagnating effect such approaches have on the adaptability of these forms and situations over time and according to circumstance. Using examples of ways that modern technologies have influenced building and design, the author emphasizes that all are inherently a part of local tradition and, due to their continued functionality, all are contemporary.

CONSIDERING PLACE

Ching, Barbara, and Gerald W. Creed, eds. *Knowing Your Place: Rural Identity and Cultural Hierarchy*. New York: Routledge, 1997.

Concerned with the limitations of viewing and understanding cultural identities from a solely urban perspective, this collection of essays explores the significance of the rural within all aspects of contemporary life. In doing so, the authors reflect upon the impact that place has on notions of class, gender, and race as well as its role in the formation of local, global, and environmental policy and the many distinctions between rural and urban.

Esche, Charles, Kerstin Niemann, and Stephanie Smith. *Heartland*. Chicago: Smart Museum of Art, in association with the University of Chicago Press, 2009.

Published in conjunction with an exhibition of the same title, this catalogue showcases the eclecticism and range of artists whose work is rooted in the interior of the United States. A series of short essays addresses topics such as musical

inheritances of the mid-South, international reflections upon Americanness, the quirks of suburban cultures and lifestyles, and new notions of creative community and artistic spaces that exist both in dense metropolises and small-town neighborhoods.

Lesy, Michael. *Wisconsin Death Trip*. New York: Pantheon Books, 1973. Reprint, Albuquerque, NM: University of New Mexico Press, 2000.

Described as an "exploration of the underworld," this book attempts to investigate the "major crisis in American life" that occurred during the last decade of the nineteenth century as chronicled by a series of photographs of rural Wisconsin life by photographer Charles Van Schaick. Firsthand accounts, newspaper clippings, and personal correspondence intercut with the photos provide a glimpse into the harsh aspects of life in the Midwest at the time.

Spraker, Jean E. "The Rollicking Realm of Boreas: A Century of Carnivals in St. Paul." *Minnesota History* (winter 1995): 322–331.

Ice palaces, King Boreas, and the Vulcans take center stage in this brief recounting of the history of the Winter Carnival in St. Paul, Minnesota. It features documentation and ephemera from the earliest carnivals through those held in the mid-1980s.

CONTEMPORARY ART AND MATERIAL CULTURE

Auther, Elissa. *String, Felt, Thread: The Hierarchy of Art and Craft in American Art*. Minneapolis, MN: University of Minnesota Press, 2010.

Auther examines fiber, post-Minimalist and feminist art, and their various usages during the surge of craft-based artistic practice in the 1960s and 1970s. By drawing out the dynamics and cultural significance of the high/low dichotomy of fine art and craft, this book richly outlays the mainstreaming of string, felt, thread, fabric, and other textiles over the past forty years.

Botterill, Jacqueline. "Cowboys, Outlaws and Artists: The Rhetoric of Authenticity

and Contemporary Jeans and Sneaker Advertisements." *Journal of Consumer Culture* 7, no. 1 (2007): 105–125.

Among the many ways that advertising has shaped how we view ourselves, particularly since the 1950s, images of jeans and sneakers have remained ultimate signifiers of "realness." From hip-hop to back-to-school to the rodeo, the branding of these two products across identities as a marker of the concept is scrutinized in this short text.

Clouse, Abby. "Narratives of Value and the Antiques Roadshow: A Game of Recognitions." *Journal of Popular Culture* 41, no. 1 (2008): 3–20.

Taking the popular television series *Antiques Roadshow* as a point of departure, the author unpacks ways that objects and their owners are inextricably linked and the power dynamics within this exchange. The notion that our histories and sense of self are embedded in these objects grants them a disproportionate amount of importance within and over our lives.

Magliaro, Joseph, and Shu Hung, eds. *By Hand: The Use of Craft in Contemporary Art.* New York: Princeton Architectural Press, 2007.

Featuring profiles of thirty-two artists and designers, this book presents their work as an elaboration on the idea that craft has reemerged as a significant practice in contemporary art. In their own words, artists Kiki Smith and Aaron Spangler, among others, detail the importance of the handmade in their practices.

Money, Annemarie. "Material Culture and the Living Room: The Appropriation and Use of Goods in Everyday Life." *Journal of Consumer Culture* 7, no. 3 (2007): 355–377.

Delving into the sociology of consumption, this article culls from and reflects upon a series of interviews with family members from fifty homes located in Manchester, England. The findings reveal ways that respondents attach meaning to objects and decoration in domestic spaces.

Perchuk, Andrew, and Rani Singh, eds. *Harry Smith and the Avant-Garde in the American Vernacular.* Los Angeles: Getty Research Institute, 2010.

This volume situates the diverse life and work of mid-twentieth-century avant-guardist Harry Smith (1923–1991) within the broader context of eccentricism and eclecticism in American art, music, and various other areas of study. Known for his *Anthology of American Folk Music* (1952), a definitive compilation complied from his extensive personal collection and released during the revival of folk music in the 1950s, Smith also worked in experimental film and abstract painting throughout his life.

Rose, Randall L., and Stacy L. Wood. "Paradox and the Consumption of Authenticity through Reality Television." *Journal of Consumer Research* 32 (2005): 284–296.

This article tackles ways that audiences project their own ideas about authenticity and cultural familiarity on the highly edited, restructured, and synopsized "reality" of reality television. Through a series of discussions with viewers of these programs, the authors trace the formation of a hyperreality as interviewees negotiate their own identity through a genre overly obsessed with reconfiguring what is considered real.

Marina Abramović
Yugoslav, b. 1946
1. *Balkan Erotic Epic: Exterior Part 1 (B)*
2005
single-channel video (color, sound) trans-
ferred to DVD; edition 2/5, 1 AP
15:22 minutes, loop
Courtesy Sean Kelly Gallery, New York

Siah Armajani
American, b. Iran, 1939
2. *Closet under Dormer* 1984–1985
wood, paint, shellac, mirror
107½ × 48 × 29¼ in.
(273.1 × 121.9 × 74.3 cm)
Collection Walker Art Center, Minneapolis
T. B. Walker Acquisition Fund. 1986

Louise Bourgeois
American, b. France, 1911–2010
3. *Untitled* 2002
tapestry, aluminum
12 × 12 × 12 in. (30.5 × 30.5 × 30.5 cm)
stainless steel, glass, wood vitrine
70 × 24 × 24 in. (177.8 × 61 × 61 cm)
Private collection
Courtesy Cheim & Read, New York

William Christenberry
American, b. 1936
4. *Palmist Building* 1979
bass and balsa woods, paper, metal, paint,
red soil
14 × 25¼ × 17 in.
(35.6 × 64.1 × 43.2 cm)
Collection the Taubman Museum of Art,
Roanoke, Virginia
Acquired with funds provided by the
Cherry Hill Endowment, with
assistance from the National Endowment
for the Arts

Shannon Ebner
American, b. 1971
5. *Landscape Incarceration* 2003
chromogenic print
32 × 40½ in. (81.3 × 102.9 cm)
Courtesy the artist, Los Angeles, and
Wallspace, New York

6. *Ampersand* 2009
chromogenic print
40½ × 32 in. (102.9 × 81.3 cm)
Collection Andrew Kreps, New York

7. *Blank Field* 2009
chromogenic print
40½ × 32 in. (102.9 × 81.3 cm)

Courtesy the artist, Los Angeles, and
Wallspace, New York

8. *The Sun as Error* 2009
chromogenic print
40½ × 32 in. (102.9 × 81.3 cm)
Courtesy the artist, Los Angeles, and
Wallspace, New York

William Eggleston
American, b. 1939
9. *Untitled* c. 1960–1965
gelatin silver print
5 × 7 in. (12.7 × 17.8 cm)
©Eggleston Artistic Trust
Courtesy Cheim & Read,
New York

10. *Untitled (Back of Black Car in Green
Vines)* from the *Los Alamos Project*
1965–1974
dye transfer print
16 × 20 in. (40.6 × 50.8 cm)
Collection Sheri and Paul Siegel
©Eggleston Artistic Trust
Courtesy Cheim & Read, New York

11. *Untitled* c. 1966–1968
gelatin silver print
10 × 8 in. (25.4 × 20.3 cm)
©Eggleston Artistic Trust
Courtesy Cheim & Read, New York

12. *Untitled (Steak Billboard) Memphis,
TN* 1973
dye transfer print
16 × 20 in. (40.6 × 50.8 cm)
©Eggleston Artistic Trust
Courtesy Cheim & Read, New York

Walker Evans
American, 1903–1975
13. *A Miner's Home, West Virginia* 1935
gelatin silver print
9¹⁵⁄₁₆ × 8 in. (25.2 × 20.3 cm)
Collection Minneapolis Institute of Arts
The William Hood Dunwoody Fund

14. *Church Interior, Alabama* 1936
gelatin silver print
7¹³⁄₁₆ × 9¹⁵⁄₁₆ in. (19.8 × 25.2 cm)
Collection Minneapolis Institute of Arts
Gift of Arnold H. Crane

15. *Negroes' Church, South Carolina*
1936
gelatin silver print
9¹⁵⁄₁₆ × 7¹⁵⁄₁₆ in. (25.2 × 20.2 cm)

Collection Minneapolis Institute of Arts
The William Hood Dunwoody Fund

16. *Roadside Stand, Vicinity Birmingham, Alabama* 1936
gelatin silver print
8 × 9¹⁵⁄₁₆ in. (20.3 × 25.2 cm)
Collection Minneapolis Institute of Arts
The William Hood Dunwoody Fund

17. *Tin Building, Moundville, Alabama* 1936
gelatin silver print
8 × 9¹⁵⁄₁₆ in. (20.3 × 25.2 cm)
Collection Minneapolis Institute of Arts
The William Hood Dunwoody Fund

Rachel Harrison
American, b. 1966
18. From *Voyage of the Beagle, Three* 2010
51 pigmented inkjet prints
18⁷⁄₁₆ × 13³⁄₈ × 1³⁄₁₆ in.
(46.8 × 34 × 3 cm) each, framed
Courtesy the artist and Greene Naftali Gallery, New York

Matthew Day Jackson
American, b. 1974
19. *November 18, 1978* 2007/2010
yarn, wood, Formica on wood
60 × 73 × 2 in.
(152.4 × 185.4 × 5.1 cm)
Courtesy the artist, Brooklyn

Butt Johnson
American, b. 1979
20. *Untitled Floral Pastiche (Snapdragon)* 2009
ballpoint pen ink on paper
9½ × 10 in. (24.1 × 25.4 cm)
Courtesy the artist and CRG Gallery, New York

21. *Untitled Floral Pastiche (Waterlily)* 2009
ballpoint pen ink on paper
10 × 9½ in. (25.4 × 24.1 cm)
Courtesy the artist and CRG Gallery, New York

William E. Jones
American, b. 1962
22. *Killed* 2009
sequence of digital files transferred to DVD (black and white, silent)
1:44 minutes
Source images from the Farm

Security Administration Collection,
Library of Congress
Courtesy the artist and David Kordansky Gallery, Los Angeles

Mike Kelley
American, b. 1954
23. *More Love Hours Than Can Ever Be Repaid* 1987
stuffed fabric toys and afghans on canvas with dried corn
96¹⁄₁₆ × 126¹⁵⁄₁₆ × 5⁷⁄₈ in.
(244 × 322.5 × 15 cm)
Collection Whitney Museum of American Art, New York
Purchase, with funds from the Painting and Sculpture Committee

24. *The Wages of Sin* 1987
wax candles on wood and metal
51¹⁵⁄₁₆ × 23¹⁄₁₆ × 23¹⁄₁₆ in.
(132 × 58.5 × 58.5 cm)
Collection Whitney Museum of American Art, New York
Purchase, with funds from the Painting and Sculpture Committee

Chris Larson
American, b. 1966
25. *Deep North* 2008
video (color, sound) transferred to DVD
8:16 minutes
Courtesy the artist, St. Paul, Minnesota

26. *Unnamed* 2010
white pine
228 × 600 × 168 in.
(579.1 × 1524 × 426.7 cm)
Courtesy the artist, St. Paul, Minnesota
[Walker Art Center only]

Kerry James Marshall
American, b. 1955
27. *Gulf Stream* 2003
acrylic, glitter on canvas
108 × 156 in. (274.3 × 396.2 cm)
Collection Walker Art Center, Minneapolis
T. B. Walker Acquisition Fund, 2004

Ree Morton
American, 1936–1977
28. *Of Previous Dissipations* 1974
oil on wood with Celastic
41 × 72⁷⁄₈ × 6½ in.
(104.1 × 185.1 × 16.5 cm)
The Museum of Modern Art, New York
Gift of Ree Morton Estate, 1988

Laura Owens
American, b. 1970
29. *Untitled* 2006
oil, acrylic, collage on linen
18 x 12 in. (45.7 x 30.5 cm)
Collection Joan and David Genser, Palm Beach, Florida

Jack Pierson
American, b. 1960
30. *Beauty* 1995
metal, plastic, neon tubing, wood, paint
20 × 133 × 5¼ in.
(50.8 × 337.8 × 13.3)
Collection Walker Art Center, Minneapolis
Clinton and Della Walker Acquisition Fund and Justin Smith Purchase Fund, 1995

Lari Pittman
American, b. 1952
31. *A Decorated Chronology of Insistence and Resignation #30* 1994
acrylic, enamel, glitter on 2 wood panels
83 × 160 in. (210.8 × 406.4 cm)
Private collection

Faith Ringgold
American, b. 1930
32. *Change 1: Weight Loss Performance Story Quilt* 1986
acrylic on canvas, photo lithography on silk and cotton pieced fabric
62 × 63 in. (157.5 × 160 cm)
The Ellen and Richard Sandor Family Collection

Dario Robleto
American, b. 1972
33. *Demonstrations of Sailor's Valentines* 2009
cut paper, various seashells, colored wax, *cartes-de-visite*, silk, ribbon, foam core, glue
59 × 52 × 6 in.
(149.9 × 132.1 × 15.2 cm)
Des Moines Art Center
Purchased with funds from Ellen Pray Maytag Madsen Sculpture Acquisition Fund, 2009

Jim Shaw
American, b. 1952
34. *Paintings Found in Oist Thrift Store (Fantasy Oism)* 2007
acrylic on canvas board
group of 7, various dimensions
Courtesy the artist and Metro Pictures, New York

35. *Paintings Found in Oist Thrift Store (Present)* 2008
acrylic on canvas board
group of 5, various dimensions
Courtesy the artist and Metro Pictures, New York

Lorna Simpson
American, b. 1960
36. *1957–2009 Interior #1* 2009
gelatin silver prints; edition 1/2, 1 AP
7 × 7 in. (17.8 × 17.8 cm) each of 15
Collection Walker Art Center, Minneapolis
T. B. Walker Acquisition Fund, 2010

37. *LA '57–NY '09* 2009
gelatin silver prints; edition 1/2, 1 AP
7 × 7 in. (17.8 × 17.8 cm) each of 25
Collection Walker Art Center, Minneapolis
T. B. Walker Acquisition Fund, 2010

Aaron Spangler
American, b. 1971
38. *Government Whore* 2009–2010
carved and painted basswood, graphite on welded steel base
93 × 42 × 16 in. (236.2 × 106.7 × 40.6 cm)
Courtesy the artist, Brooklyn, and Horton Gallery, New York

39. *I Owe My Soul To The Company Store* 2009–2010
carved and painted basswood, graphite on welded steel base
77 × 44 × 16 in.
(195.6 × 111.8 × 40.6 cm)
Courtesy the artist, Brooklyn, and Horton Gallery, New York

40. *To The Valley Below* 2009–2010
carved and painted basswood, graphite on welded steel base
77 × 44 × 16 in.
(195.6 × 111.8 × 40.6 cm)
Courtesy the artist, Brooklyn, and Horton Gallery, New York

Marc Swanson
American, b. 1969
41. *Untitled (Looking Back Buck)* 2004
crystals, polyurethane foam, adhesive; AP 1/2 from an edition of 5
36 × 18 × 18 in.
(91.4 × 45.7 × 45.7 cm)
Courtesy the artist and Richard Gray Gallery, Chicago

42. *Untitled (Antler Pile)* 2010
antlers, crystals, adhesive
31 × 29 × 29 in.
(78.7 × 73.7 × 73.7 cm)
Private collection, Paris

Jeffrey Vallance
American, b. 1955
43. *Blinky Bone* 2006
mixed media
23 × 13³/₄ × 5¹/₂ in. (58.4 × 34.9 × 14 cm)
Courtesy the artist and Tanya Bonakdar
Gallery, New York

44. *Bloody Blanket (Performance Relic)*
2006
mixed media
16¹/₈ × 10¹/₄ × 4⁵/₈ in. (41 × 26 × 11.7 cm)
Courtesy the artist and Tanya Bonakdar
Gallery, New York

45. *Vladimir Lenin: Relics of the USSR*
2006
mixed media
17¹/₂ × 14³/₈ × 8¹/₄ in. (44.5 × 36.5 × 21 cm)
Courtesy the artist and Tanya Bonakdar
Gallery, New York

Kara Walker
American, b. 1969
46. Selections from *Harper's Pictorial
History of the Civil War (Annotated)*
2005
offset lithograph, screenprint on paper
36 x 53 in. (99.1 x 134.6 cm) each of 11
53 × 39 in. (134.6 × 99.1 cm) each of 4
Collection Walker Art Center, Minneapolis
T. B. Walker Acquisition Fund, 2005

LENDERS TO THE EXHIBITION

Cheim & Read, New York
CRG Gallery, New York
David Kordansky Gallery, Los Angeles
Des Moines Art Center, Des Moines, Iowa
Joan and David Genser, Palm Beach, Florida
Greene Naftali Gallery, New York
Horton Gallery, New York
Matthew Day Jackson, Brooklyn
Andrew Kreps, New York
Chris Larson, St. Paul, Minnesota
Metro Pictures, New York
Minneapolis Institute of Arts, Minneapolis
The Museum of Modern Art, New York
Private collection, California
Private collection, New York
Private collection, Paris
Richard Gray Gallery, Chicago
The Ellen and Richard Sandor Family Collection
Sean Kelly Gallery, New York
Sheri and Paul Siegel
Tanya Bonakdar Gallery, New York
Taubman Museum of Art, Roanoke, Virginia
Walker Art Center, Minneapolis, Minnesota
Wallspace, New York
Whitney Museum of American Art, New York

IMAGES

Page 14 Courtesy the National Archives, photo no. 412-DA-9009

Page 16 Art ©Jasper Johns/Licensed by VAGA, New York, NY; Collection Jean-Christophe Castelli

Page 21 Installation view, *Government Whore*, Horton Gallery, Chelsea, New York, 2010; photo: Mark Woods

Page 22 Chromogenic print mounted on aluminium composite panel, courtesy the artist and Galerie Magnus Müller, Berlin

Page 23 Photos: Gene Pittman, Walker Art Center

Page 25 Courtesy the artist and Metro Pictures, New York

Page 27 Courtesy the artist and Metro Pictures, New York; installation view, Carnegie Museum of Art, Pittsburgh, 1991; photo: Eric Baum

Page 28 Courtesy the artist and Tanya Bonakdar Gallery, New York

Page 31 ©1962 Claes Oldenburg and Coosje van Bruggen; Collection Walker Art Center, Minneapolis; Purchased with the aid of funds from the National Endowment for the Arts and Art Center Acquisition Fund, 1979; photo: Glenn Halvorson, Walker Art Center

Page 32 Photo: Gene Pittman, Walker Art Center

Page 33 ©Ree Morton; courtesy Alexander and Bonin Gallery, New York; photo: Markus Wörgötter

Page 38 Source image (1937) by John Vachon from the Farm Security Administration Collection, Library of Congress; courtesy the artist and David Kordansky Gallery, Los Angeles

Page 42 Photo: Glenn Halvorson, Walker Art Center

Page 43 Collection the Taubman Museum of Art, Roanoke, Virginia; Acquired with funds provided by the Cherry Hill Endowment, with assistance from the National Endowment for the Arts, 1990.001.001

Pages 44–45 Courtesy the artist and Horton Gallery, New York; photo: Mark Woods

Page 47 ©Walker Evans Archive, Metropolitan Museum of Art; courtesy Minneapolis Institute of Arts, The William Hood Dunwoody Fund

Page 49 Courtesy the artist, Brooklyn

Pages 50–51 Photo: Glenn Halvorson, Walker Art Center

Pages 52, 54–55 ©The Eggleston Artistic Trust; courtesy the artist, Memphis, and Cheim & Read, New York

Page 53 Collection Sheri and Paul Siegel ©The Eggleston Artistic Trust; courtesy the artist, Memphis, and Cheim & Read, New York

Page 56 Collection Andrew Kreps; courtesy the artist and Wallspace, New York

Pages 57–59 Courtesy the artist, Los Angeles, and Wallspace, New York

Page 60 Courtesy the artist and Gavin Brown's Enterprise, New York

Page 61 ©Butt Johnson; courtesy the artist and CRG Gallery, New York

Pages 62–63 ©Ree Morton; digital image ©The Museum of Modern art/Licensed by SCALA/Art Resource, NY

Pages 64–65 Photos: Gene Pittman, Walker Art Center

Pages 66–69 Source images (1937–1939) by John Vachon from the Farm Security Administration Collection, Library of Congress; courtesy the artist and David Kordansky Gallery, Los Angeles

Page 71 Courtesy Cheim & Read, New York; photo: Christopher Burke

Pages 72–73 Courtesy Faith Ringgold ©1986

Pages 74–75 Courtesy the artist and Greene Naftali Gallery, New York

Pages 76–77 ©Marina Abramović; courtesy Sean Kelly Gallery, New York

Pages 78–79 Courtesy the artist and Richard Gray Gallery, Chicago

Pages 80–81 Courtesy the artist and Galerie Magnus Müller, Berlin

Pages 82–83 Courtesy the artist and Tanya Bonakdar Gallery, New York

Pages 84–87 Courtesy the artist and Metro Pictures, New York

Pages 88–89 Courtesy the artist and Jack Shainman Gallery, New York; photo: Cameron Wittig, Walker Art Center

Pages 90–91 Courtesy the artist and Salon 94, New York

Pages 92–93 Courtesy the artist, Metro Pictures, and the Whitney Museum of American Art, New York; photo: Sheldan C. Collins

Page 95 Courtesy the artist and Des Moines Art Center, Des Moines, Iowa

Pages 96–97 ©Lari Pittman; courtesy Regen Projects, Los Angeles

Page 101 ©Walker Evans Archive, Metropolitan Museum of Art; courtesy Minneapolis Institute of Arts, The William Hood Dunwoody Fund

Page 104 Courtesy the Minnesota Historical Society, Location no. HE3.8 r28, Negative no. 102147

Page 107 Courtesy the Minnesota Historical Society, Location no. MW7.9 WN6 r7, Negative no. 102153

Page 108 Courtesy the Minnesota Historical Society, Location no. MB4.9 BJ6 r16

REPRODUCTION CREDITS

Page 111 Courtesy the Minnesota Historical Society, Location no. Runk 1336

Page 114 Courtesy the Minnesota Historical Society, Location no. MC10.9 BR6 r7

Page 117 Courtesy the Minnesota Historical Society, Location no. MI8.9 BF r3, Negative no. 7967-A

ARTIST QUOTES

Page 42 Siah Armajani quoted in Murtaza Vali, "Return to Exile," *ArtAsiaPacific* 69 (July/August 2010): 105.

Page 43 William Christenberry quoted in Robert Hirsch, "The Muse of Place and Time: An Interview with William Christenberry," in *Afterimage* 33, no. 3 (November/December 2005): 32.

Page 44 Aaron Spangler, excerpt from an e-mail message to Darsie Alexander, December 9, 2010.

Page 46 Walker Evans, handwritten draft memorandum regarding a Resettlement Administration job (spring 1935) as reprinted in Walker Evans, *Walker Evans at Work* (New York: Harper & Row, 1982), 112.

Page 48 Matthew Day Jackson quoted in Bill Arning, "Matthew Day Jackson: Mens et Manus," in *Flash Art International* (January/February 2010): 68.

Page 50 Jack Pierson quoted in Veralyn Behenna, "Jack Pierson: Little Triumphs of the Real," in *Flash Art International* (March/April 1994): 88.

Page 52 William Eggleston quoted in Thomas Weski, "I Can't Fly but I Can Make Experiments," in *William Eggleston: Democratic Camera, Photographs and Video, 1961–2008* (New Haven, CT: Yale University Press, 2008), 17.

Page 56 Shannon Ebner, excerpt from an e-mail message to Camille Washington, December 4, 2010.

Page 60 Laura Owens quoted in Rachel Kushner, "Interview with Laura Owens," in *The Believer* 1, no. 2 (May 2003).

Page 61 Butt Johnson, excerpt from an e-mail message to Darsie Alexander, December 8, 2010.

Page 62 Ree Morton, excerpt from the artist's notebook (1974) as reprinted in Allan Schwartzman and Kathleen Thomas, eds., *Ree Morton: Retrospective 1971–1977* (New York: New Museum, 1980), 45.

Page 64 Kara Walker quoted in Alexander Alberro, "Kara Walker," *Index* 1 (February 1996): 28.

Page 66 William E. Jones, excerpt from "Puncture Wounds," in *Killed: Rejected Images of the Farm Security Administration* (New York: PPP Editions, 2010).

Page 70 Louise Bourgeois quoted in Frances Morris, *Louise Bourgeois: Stitches in Time* (London and Dublin: August Projects and Irish Museum of Modern Art, 2003), 25.

Page 72 Faith Ringgold, excerpt from the text "Change: Faith Ringgold's Over 100 Pounds Weight Loss Story Quilt" in the work *Change 1: Weight Loss Performance Story Quilt*, 1986. Courtesy Faith Ringgold ©1986.

Page 74 Rachel Harrison, excerpt from an e-mail message to Camille Washington, January 12, 2011.

Page 77 Marina Abramović quoted in Jörg Heiser, "Do it Again," in *Frieze* 94 (October 2005): 179.

Page 78 Marc Swanson, excerpt from an e-mail message to Darsie Alexander, December 2, 2010.

Page 81 Chris Larson quoted in Sönke Magnus Müller, ed., *Chris Larson: Failure* (Ostfildern, Germany: Hatje Cantz, 2009), 57.

Page 83 Jeffrey Vallance, excerpt from "Relics and Reliquaries," in *Jeffrey Vallance: Relics & Reliquaries* (Santa Ana, CA: Grand Central Press, 2008), 11.

Page 84 Jim Shaw, excerpt from an e-mail message to Darsie Alexander, January 4, 2011.

Page 88 Kerry James Marshall quoted in "Kerry James Marshall and Arthur Jafa: Fragments from a Conversation, June–July 1999," in Terrie Sultan, *Kerry James Marshall* (New York: Harry N. Abrams, 2000), 90.

Page 90 Lorna Simpson, excerpt from artist talk at the Walker Art Center, May 13, 2010.

Page 93 Mike Kelley, excerpt from "In the Image of Man (1991)," in *Mike Kelley*, John C. Welchman, Isabelle Graw, and Anthony Vidler, eds. (London: Phaidon, 1999), 128.

Page 94 Dario Robleto, excerpt from a conversation with Darsie Alexander, May 20, 2010.

Page 96 Lari Pittman, excerpt from an e-mail message to Darsie Alexander, June 9, 2010.